LEE-ON-THE-SOLENT

From Old Photographs

RON BROWN

AMBERLEY

Also by Ron Brown for Amberley Publishing

The Pubs of Portsmouth
The Cinemas & Theatres of Portsmouth
Portsmouth Transport

First published 2011

Amberley Publishing
The Hill, Stroud
Gloucestershire, GL5 4EP

www.amberleybooks.com

British Library Cataloguing in Publication Data.
A catalogue record for this book is available from the British Library.

ISBN 978 1 4456 0154 0

Typesetting and Origination by Amberley Publishing.
Printed in Great Britain.

Contents

Acknowledgements

Although most of the photographs in this book are from my own collection accumulated over forty years, I am indebted to the following names for additional photographic material: The Portsmouth *News*, Mrs M. Barnicott, Margaret Coombs, Bernie Cooper, Jeremy Nelson, Len Prestige, Arthur Smith, and the late David Lawrence.

Further Reading

Ron Brown, *The Story of Lee-on-the-Solent*, Milestone, 1982.
Lesley Burton and Beryl Peacey, *Lee-on-the-Solent*, Chalford, 1997 (archive photographs).

About the Author

Ron Brown will need no introduction to local history enthusiasts in the Portsmouth area, for in a period spanning over thirty years he has produced hundreds of local newspaper articles and columns, in addition to twenty-four books. A former showbiz and jazz critic, he also produced *Georgia on My Mind – The Nat Gonella Story* (1985) and the sequel *Nat Gonella – A Life In Jazz* (2005). Ron's previous books for Amberley Publishing include *The Pubs of Portsmouth* (2009), *The Cinemas & Theatres of Portsmouth* (2009), and *Portsmouth Transport* (2010).

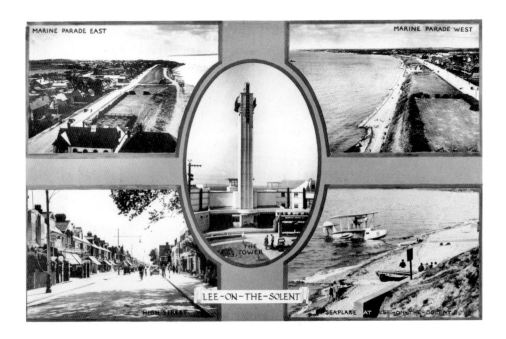

Introduction

Situated between Portsmouth and Southampton on the Hampshire coastline, Lee-on-the-Solent is a small seaside town that looks across the Solent to the green hills of the Isle of Wight some three miles beyond. For over eighty years Lee has formed part of the Borough of Gosport; prior to this it was in the Parish of Crofton, but it was an uneasy liaison and Lee became something of a pawn in a game of power between Gosport and Fareham. The situation was resolved in 1930 when Gosport was able to extend its boundaries to the west and north to incorporate Lee and Rowner.

Lee-on-the-Solent was primarily a late Victorian development and prior to 1884 it may be described as a sleepy fishing village surrounded by a scattering of small farms. That said, today we can still admire two reminders of Lee's early history in the form of the medieval Le Breton Farmhouse in Manor Way and the nearby sixteenth-century Court Barn Farmhouse. The former is a private residence, while the latter has served as headquarters for the local Conservative Club for many years. The name of the aforementioned road, Manor Way, refers to an ancient manor house that once graced this area until it burned down, several centuries ago.

The more familiar story of Lee-on-the-Solent began in 1884 when Charles Robinson, a son of wealthy Dorset businessman Sir John Robinson, was sailing on his yacht out in the Solent when his eyes were drawn to Lee's then relatively untouched beach and cliffs, sparking in Charles the brainwave that this part of the coast would be ideal to develop as a seaside resort.

Returning to his family home at Newton Manor, Charles related his ideas to his father and persuaded him to fund the venture. Over the following twenty-five years or so, the Robinson family invested a considerable amount of money into developing Lee as a watering spa which would attract businesses here and encourage members of affluent families to take up permanent residence in the new resort.

The first phase of the development was the provision of a coastal road in the form of the Marine Parade. Stretching over a mile east and west, it did indeed provide an impressive promenade flanked by a backdrop of imposing red-brick villas, a dwindling number of which may still be seen along the seafront.

The next phase was introduced in 1888 with the construction of a 750-foot-long pleasure pier; this was followed by the arrival of the railway in 1894, a necessity for any aspiring seaside place. A sizeable open-air swimming pool was opened on the seafront in the early 1930s and a few years later, in 1935, the impressive Art Deco-style Lee Tower entertainment complex was opened at the entrance to the pier. The complex comprised a cinema, ballroom, restaurant, and a lift which carried visitors up the 120-foot-high tower to an observation platform at the top which afforded outstanding views of the Solent.

Thanks to the setting up of a seaplane base from 1915, Lee-on-the Solent can also claim to have played an important contribution in the history of British aviation

over a period spanning more than eighty years, chiefly through the presence of the Fleet Air Arm and HMS *Daedalus*.

Reflecting on the aforementioned attractions, you might think today that Lee has lost so much in its relatively short history. True, it no longer has a pier, railway, swimming pool, cinema, or a fully operational military airfield. We have also lost so many of those once-grand old Victorian villas along the seafront, for on inspecting the pictures in this book, the reader will note that the captions frequently include the words: 'Demolished to make way for a block of flats'.

However, we cannot live in the past; besides which, it is not all doom and gloom, for the Lee of today is still a great place in which to live, work and play. The latter is confirmed by the huge number of people who flock to its beaches in the summer months, and not simply for swimming and paddling, for it is also a popular venue for surfing and jet skiing, as well as boating.

Over the past thirty years or so Lee has expanded tremendously on the housing front, one of the more recent developments being the huge Cherque Farm Estate, which boasts over 1,000 dwellings. Lee residents, new and old, are well catered for with a thriving golf club, tennis and squash club, sailing club, fishing club, and even a gliding centre where it is possible to book flights from an area of the old airfield.

To sum up the story of Lee-on-the-Solent, I am pleased to employ the words of renowned broadcaster Wilfred Pickles, who came here in 1961 to record his *Have a Go* radio show. During his stay, in praising Lee, Wilfred declared that it must be 'A reet grand place to live in!' Even though the town has lost so much, I feel that this sentiment still holds good – long may it continue.

SOME OF THE BEAUTIES AT LEE-ON-SOLENT

one

Street Life

A pebble
on the Beach
at **LEE·ON·SOLENT**

PIER STREET.

For the local historian, picture postcards from years long past can prove invaluable when making comparisons with life as it is today, especially cards depicting street scenes, for we have lost so many historic buildings to modern development schemes. Lee-on-the-Solent is a prime example, certainly when one looks back on its main thoroughfare, the Marine Parade, where once-grand old villas have fallen to the demolition hammer and been replaced by an extensive parade of retirement flat blocks overlooking the sparkling waters of the Solent. If our Victorian predecessors, who had such grandiose dreams for Lee, could return and see this coastal town as it is today, they would no doubt raise their hands in horror, but one can't stop progress. However, when one moves back from the waterfront, by studying many of the photographs in this section of the book it is still possible to identify the original buildings, especially in Lee High Street; if you look up above the modern shopfronts, windows and chimney pots can prove helpful when making comparisons.

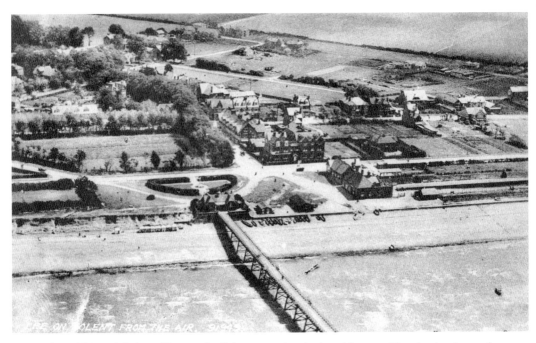

Above: This aerial view of Lee-on-the-Solent was taken in the mid-1920s. The pier dominates the foreground and the railway station and line can be seen on the right, but much of the background was open land and still waiting to be developed.

Below: Captured from the air in the 1930s, this view features Marine Parade East at the end. Cambridge Road runs off the seafront at the left and bends to extend eastwards, while at the top right of the photograph the Lee Council School can be seen along with Gosport Road.

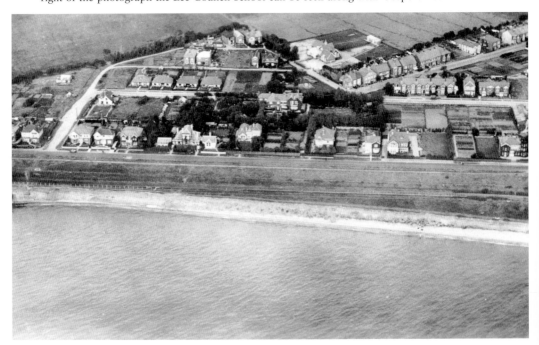

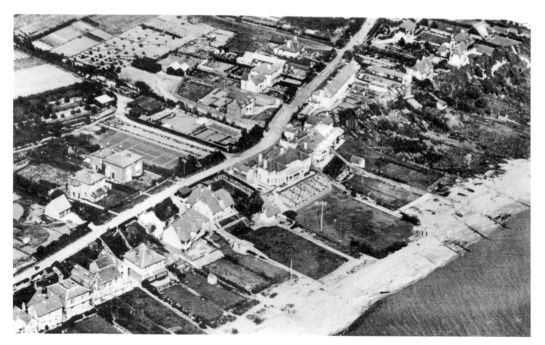

Above: Another aerial shot of the coastline, which is titled 'Hill Head, Lee-on-Solent, From The Air', and it does indeed provide a fine view taken east of Lee with Hill Head Road clearly defined. This area is now officially under the control of Fareham borough.

Below: A viewcard of Lee taken in the 1950s with the Lee Tower complex still flourishing on the seafront, although the pier is no longer to be seen. The Spinnaker Café, now flats, is at the lower right of picture.

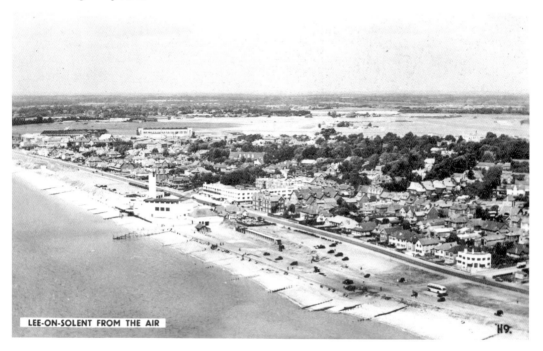

LEE-ON-SOLENT FROM THE AIR

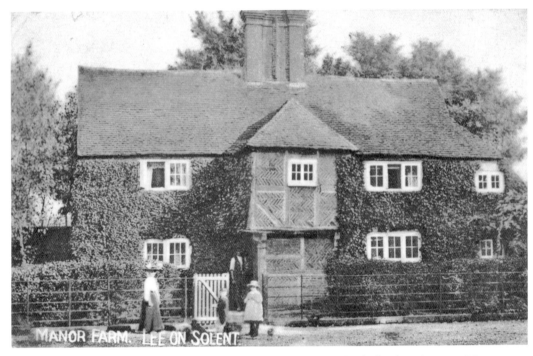

Above and below: A fine example of Jacobean architecture built of Isle of Wight stone, Manor Farm, or Le Breton Farmhouse, can still be admired today in Manor Way, Lee. Both photographs are dated *c*. 1910.

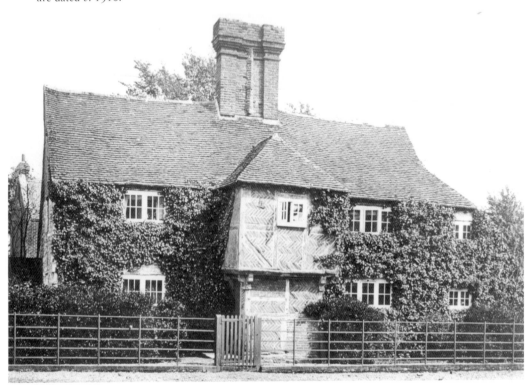

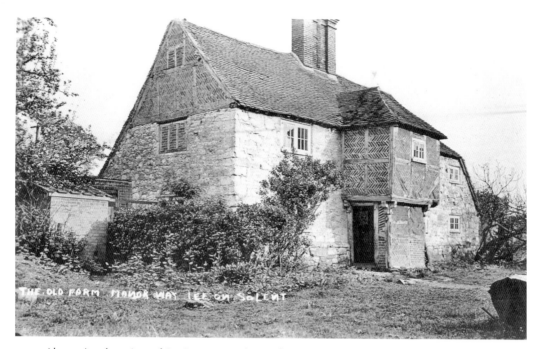

Above: Another view of Le Breton Farmhouse from the side of this historic building, taken *c.* 1920.

Below: A countrified Manor Way, a contrast with this road today, now that hundreds of motorists drive back and forth daily to and from Fareham.

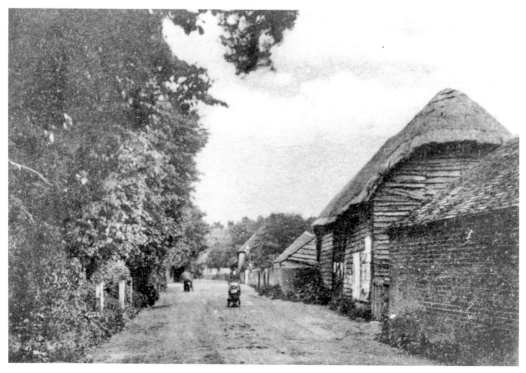

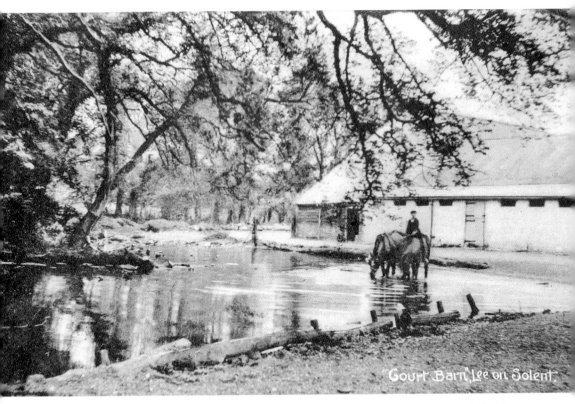

Above and below: Court Barn Farm, Lee-on-the-Solent, captured in the days before house development in Lee really began to encompass the area and scenes such as this were lost forever.

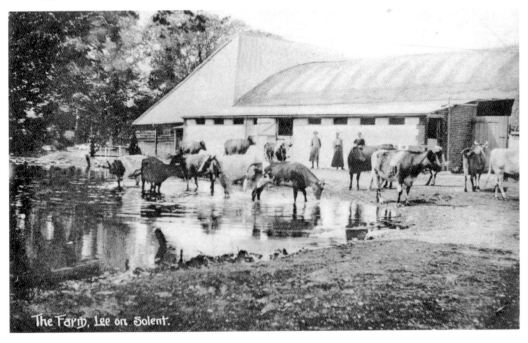

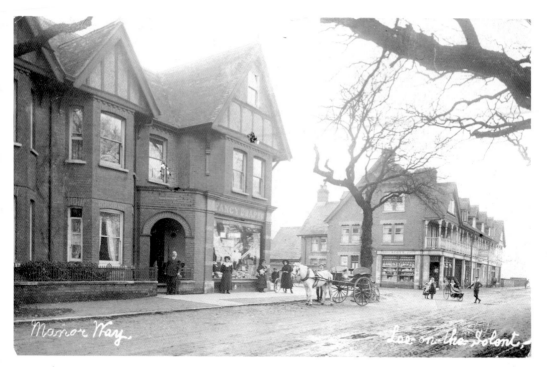

Above: A photograph, dated *c.* 1908, of Manor Way at its junction with Lee High Street. This road is one of the few still existing reminders of the Manor House that once occupied the area, although this burnt down centuries ago.

Below: An early 1900s view of Manor Way, as seen from the High Street looking north.

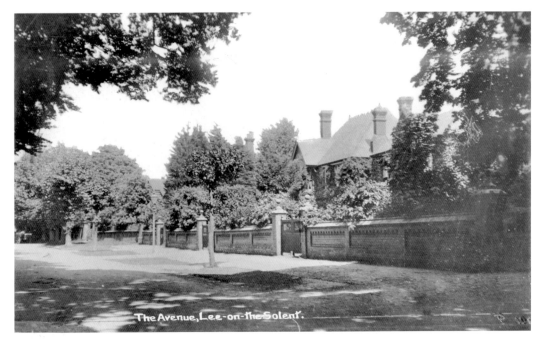

Above: Another photograph of Manor Way, although the postcard publisher refers to it as The Avenue. This was taken in 1912 and thankfully these imposing residences can still be admired today.

Below: The Royal Naval School in Manor Way, *c.* 1905. Known as Edinburgh House, the principal of this establishment was a Mr J. Cruickshank, a Scotsman who first came to Lee in 1891.

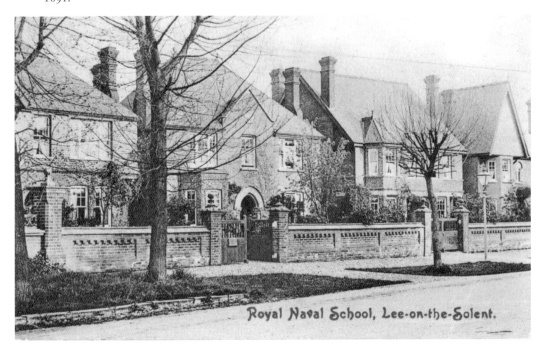

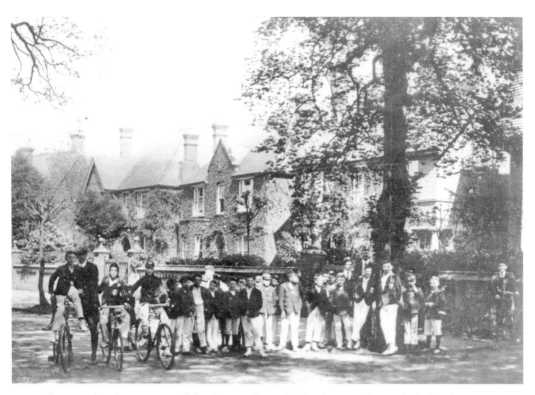

Above: Cadets from Mr Cruickshank's Royal Naval School pose in front of Edinburgh House, Manor Way.

Below: Trafalgar House, Lee-on-the-Solent. In the early 1900s this was an elite private school for boys, which the proprietor, Mr William Webb, described as 'A Young Gentlemen's Boarding School'.

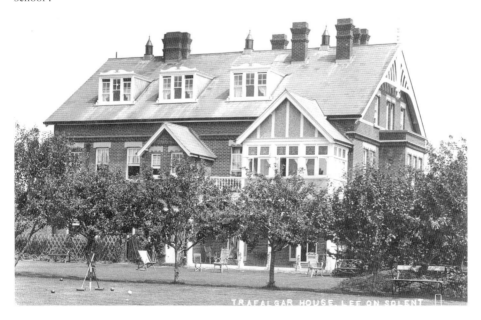

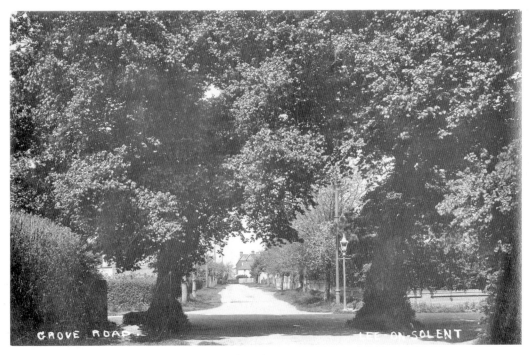

Above: A tree-lined Grove Road, Lee-on-the-Solent, *c.* 1910.

Below: Another photograph of Manor Way (The Avenue) in 1905. Sadly, long gone are the days when one could stand and pose for the camera in the middle of the road.

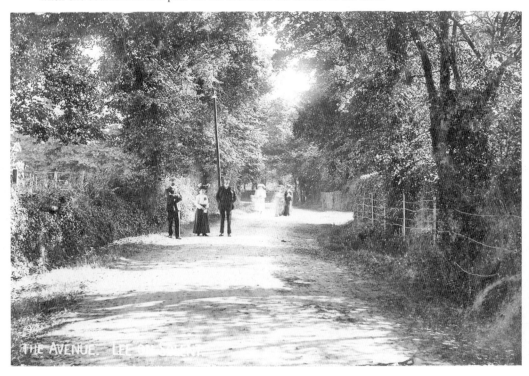

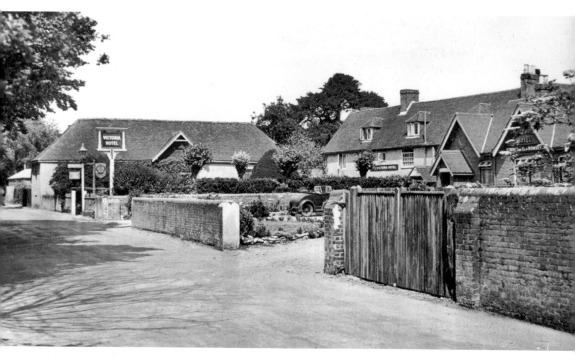

Above and below: The Victoria Hotel in Manor Way, Lee's oldest hostelry. This popular pub is still trading today, although under a different name, the Bun Penny.

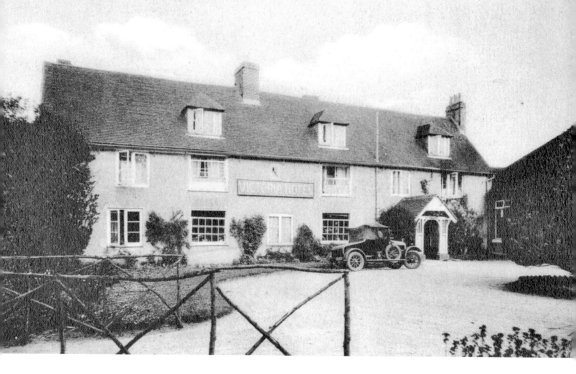

LEE-ON-THE-SOLENT.

Nov. 3rd 190 5

VICTORIA HOTEL,

H. W. SMITH - Proprietor.

BILLIARDS. ✳ **POSTING.**

Phaeton 1½ hrs
Do. Gosport return ⎱ 11/6

Paid
to Mr Coker
Manager
to Mr Smith
with
thanks

A billhead for the Victoria Hotel dated 1905, when Mr H. Smith was the proprietor. Mr Smith also ran a carriage-hire service from the hotel; the above bill for 11s 6d relates to a hire to Gosport and back lasting one and a half hours.

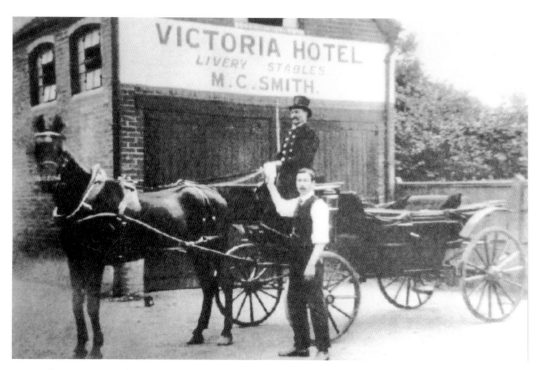

Above: By 1910 the Victoria Hotel livery stables were being run by Mr M. C. Smith, seen here posing with one of his carriages. The driver is Mr William Nelson.

Below: The Bun Penny, formerly the Victoria Hotel, in 2010. Compared with the earlier pictures, the exterior has hardly been altered over one hundred years.

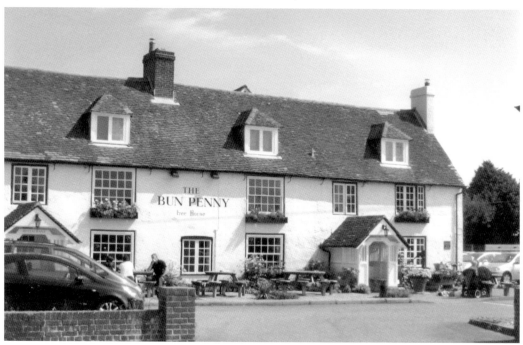

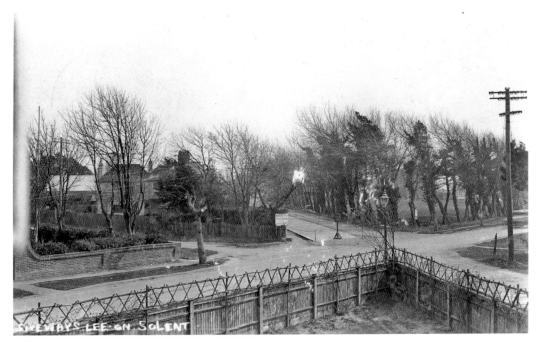

Above: This rare 1930s photograph was taken before the area on the right showing Lee High Street was developed by shops and waterfront flats. The location was referred to as 'Five Ways'. This picture was captured from the corner of Milvil Road and Montserrat Road at the junction with Grove Road and the High Street.

Below: The Hove-To Café at the western end of the High Street.

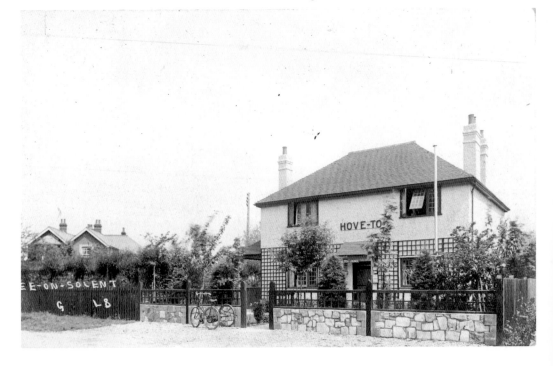

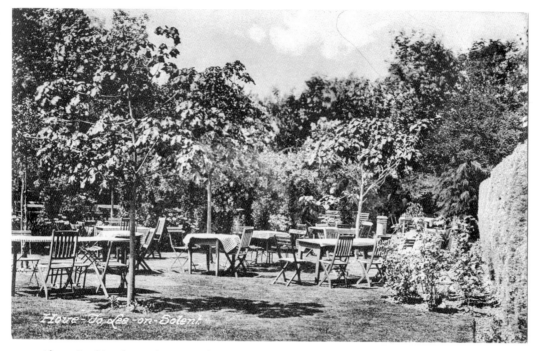

Above: Looking forward to a good summer, the Hove-To tea gardens and pleasure grounds are pictured in the 1920s. Although sited on a triangle plot on the corner of Grove Road and the High Street, the café also had a tennis court for patrons' use.

Below: The western end of Lee High Street; the Hove-To may be seen at the far end of the shops, prior to the petrol station being built there.

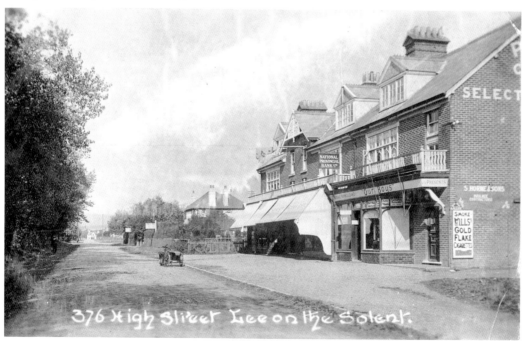

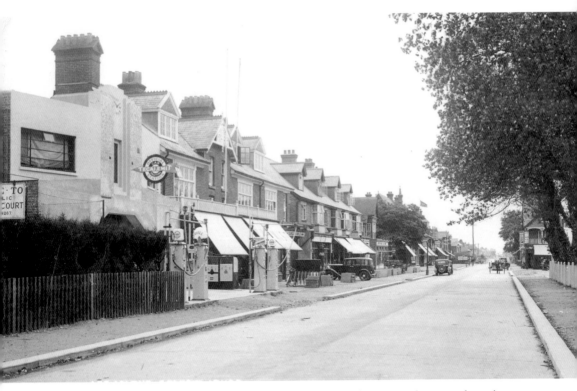

Above and below: Two viewcards of Lee-on-the-Solent High Street in the 1930s from the same position. Of particular interest is the garage and petrol station on the left of the picture; this was run by the Smith Brothers at the west end of Lee's main thoroughfare. The garage has long since disappeared and the site now houses a block of flats, Hove Court.

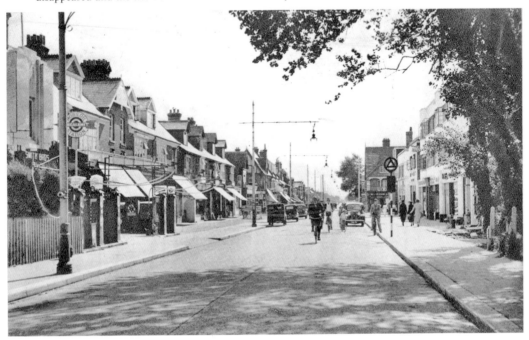

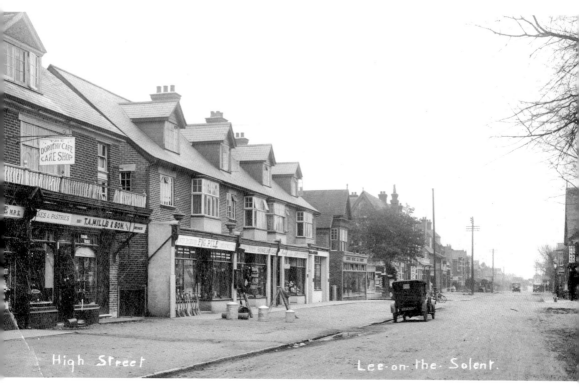

High Street Lee-on-the-Solent.

Above and below: Two similar views of Lee High Street, looking east. In the top photograph Sillitoe's chemist store and the Dorothy Café can be seen on the extreme left, while in the centre we have Fred Pile's hardware emporium, which was later taken over by Major's. In the lower picture the photographer has turned slightly clockwise from the same spot to include Pink's grocery store on the corner of Pier Street.

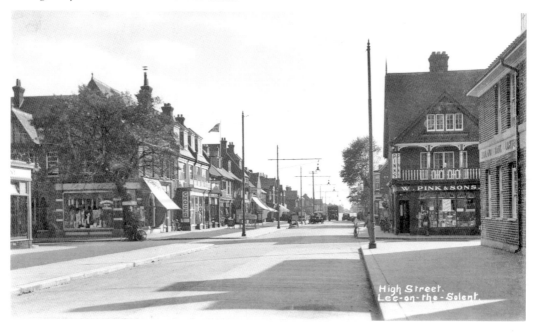

High Street. Lee-on-the-Solent.

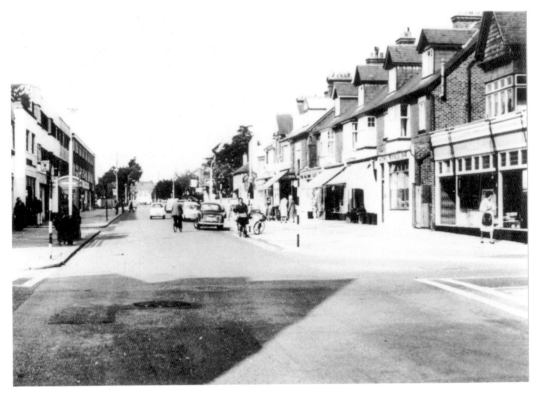

Above: Lee High Street looking west from the junction with Pier Street and Manor Way in the post-war years. The old Gosport District Gas Company showroom can be seen on the extreme right.

Below: Taken from the same junction as above but looking east, this earlier view takes in Bulson's Corner. The tree on the left is painted to advertise Bulson's Tearooms.

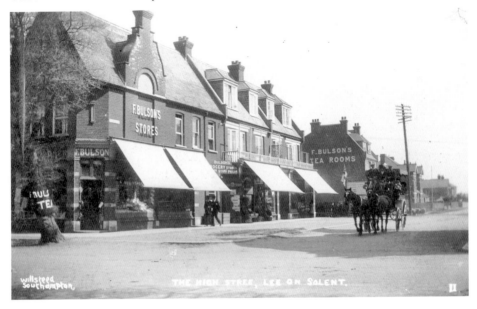

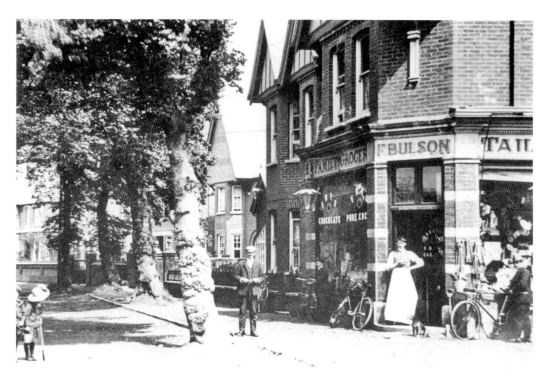

Above: Bulson's Stores on the corner of the High Street and Manor Way, *c.* 1912. The Bulson family created a mini commercial empire that was the closest Lee got to a department store in its main street.

Below: Frederick Bulson was no doubt the driving force behind this Lee emporium, which comprised a grocery store, hardware store, men's and ladies' outfitters, stationers, and even a popular tearoom all sited in one adjoining block along the High Street.

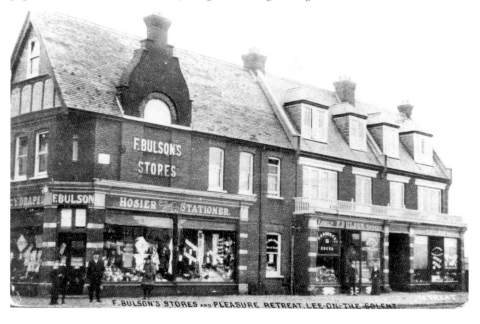

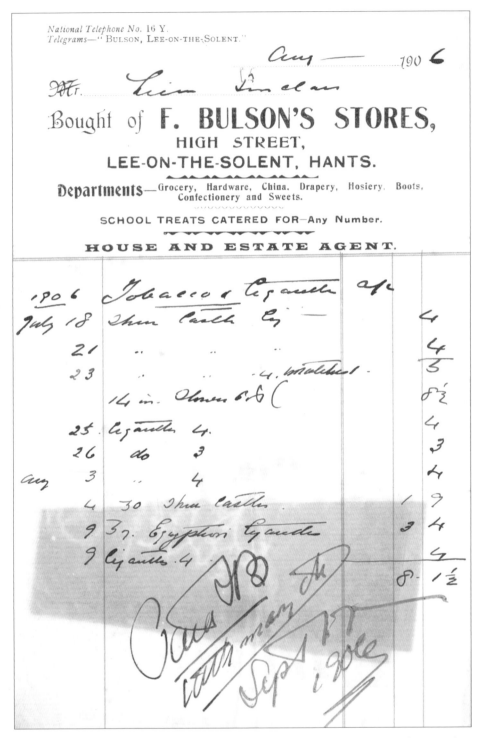

A Bulson's Stores receipt dated August 1906. This was the monthly account for providing tobacco, cigarettes and cigars to Lieutenant Sinclair, a Lee resident who must have been a heavy smoker according to the bill, which came to 8s 1½d.

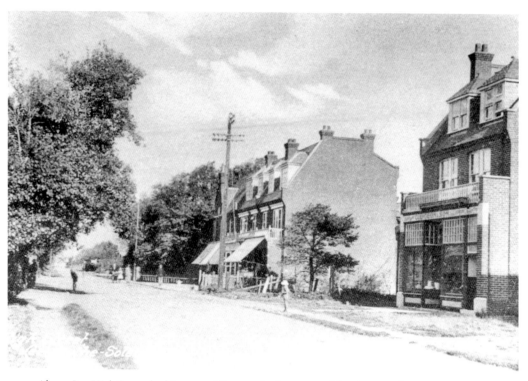

Above: Lee High Street, looking west. The trees in the centre of the picture, taken *c.* 1912, are on the corner of Manor Way, where the gas showroom was later erected. The gap between the shops is still awaiting development.

Below: Taken from more or less the same location as above. Judging by the car and distant vans, this view is dated to about the 1940s, when the gas showroom was still trading.

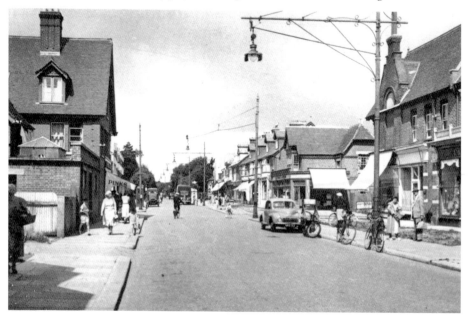

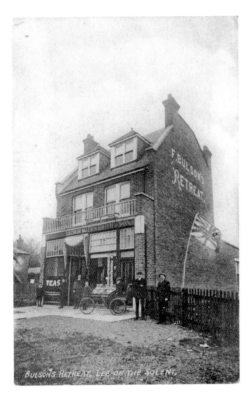

Left: Bulson's Retreat and tearooms in the High Street *c.* 1910 with Fred Bulson standing proudly by the flag. The Lee-on-the-Solent Hall had its entrance door at the centre of this building, while next door on the right we had renowned newsagent and bookseller W. H. Smith & Son.

Below: A monthly account bill for W. H. Smith dated 1906. It is interesting to note that at that time, Smith's also ran the Lee post office.

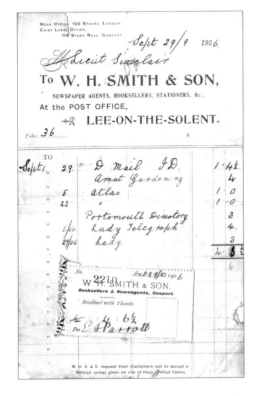

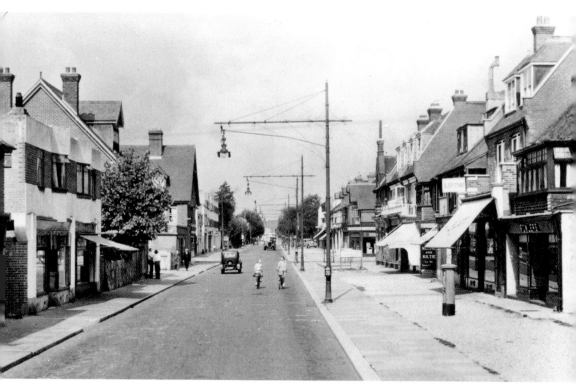

Above and below: Two more views of Lee High Street taken in the late 1930s or 1940s, looking west. By this period the Bulson empire had diminished somewhat, but in the block of shops on the right of both photographs we find that Percy Bulson's grocery store is still flourishing. Photographer Ethel Blakey also had her studio here.

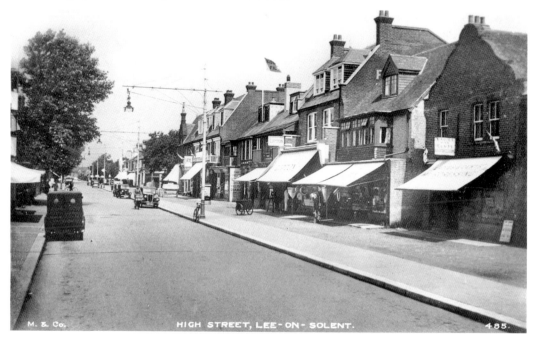

M. & Co. HIGH STREET, LEE-ON-SOLENT. 485.

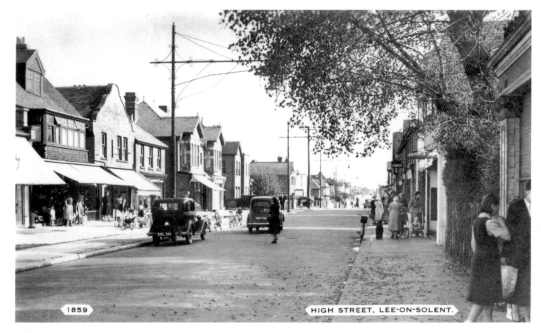

Above: High Street, looking east. The shops on the right include a Portsea Island Mutual Co-operative grocery store, and some sixty years on a Co-operative supermarket still operates from this location.

Below: This 1930s shot of the High Street, looking west, was captured from the most easterly end of the shops. On the extreme left we have the Solent Dairy Shop, which at one time was run by Dyer's Gosport Dairy, and other stores in the photograph include Galloway's fruit and veg shop and the Tudor's Gowns shop.

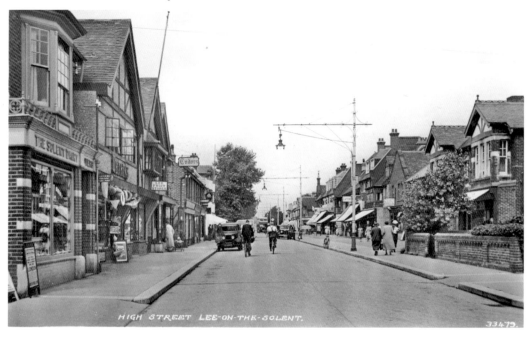

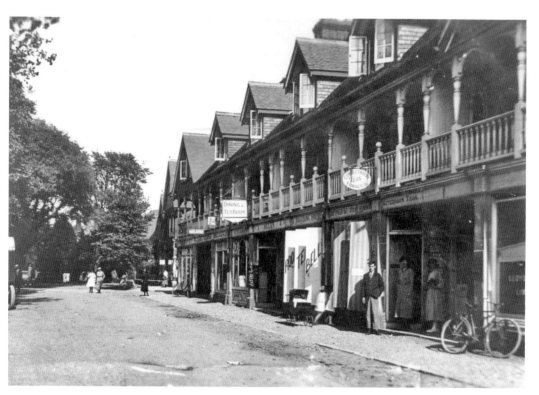

Above: An inter-war view of Pier Street; it will be noted that the road surface and pavement were still in fairly basic, unmade condition. This Lee street was very much self-contained in times past, with a grocer's, café, sweetshop, newsagent, and even a bank.

Below: Another photograph of Pier Street in the 1930s. This road to the front has hardly changed and the buildings are still clearly recognisable.

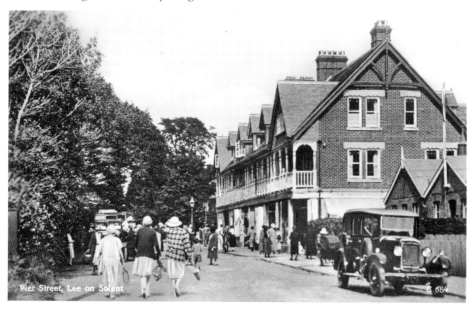

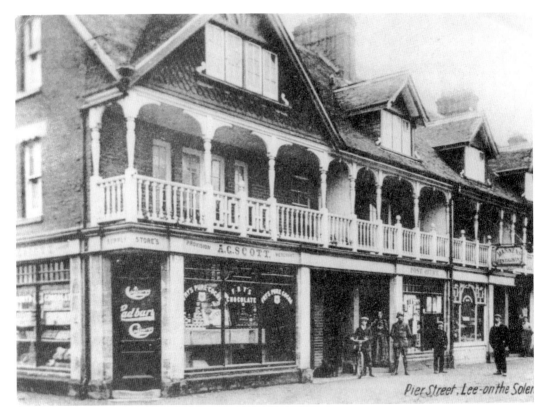

Above: This photograph of Pier Street was captured around 1913, when Scott's ran the grocery emporium on the corner of Pier Street with the High Street, a business later taken over by Pink's, the Portsmouth grocery chain.

Below: A viewcard of Pier Street taken from the seafront.

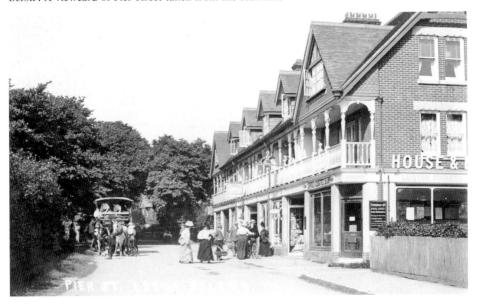

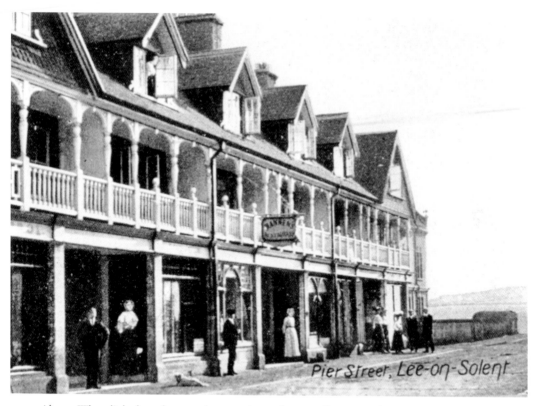

Above: When linked to the top photograph on the preceding page, this picture completes an overall view of the east side of Pier Street looking down to the seafront.

Below: Pier Street from the Marine Parade in the 1920s. The presence of a traffic patrolman would suggest that the picture was taken on a Bank Holiday.

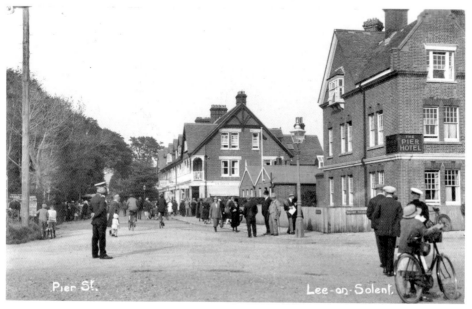

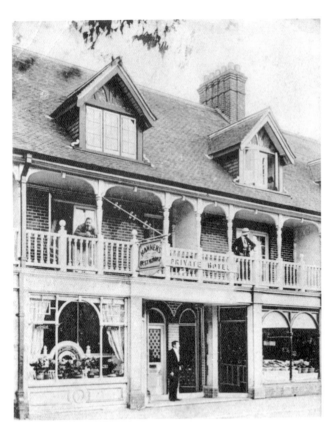

Left: Hannen's Private Hotel in Pier Street, 1905. Like the Bulsons, the Hannen family had a number of commercial interests in Lee; in addition to the hotel in Pier Street, at one time they ran the large hotel on the corner of Marine Parade East.

Below: Hannen's Hotel, which was known later as the Pier Hotel and later still as Pier House retirement home.

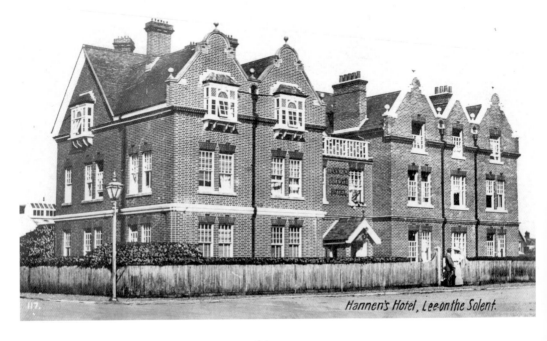

Hannen's Hotel, Lee-on-the-Solent.

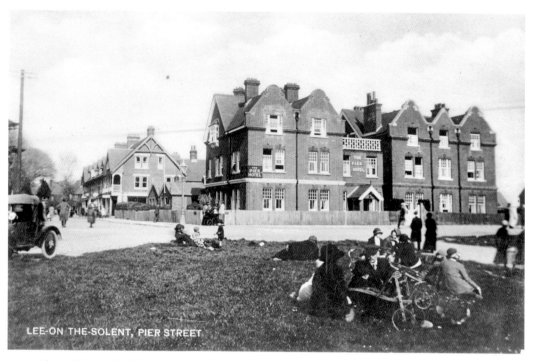

Above: Viewcard of the Pier Hotel from Marine Parade in the 1920s.

Below: A unique photograph of the former Pier Hotel/House, part-demolished in 2010 for conversion to fourteen new luxury apartments. The façade has been preserved, but the development behind it will be entirely new.

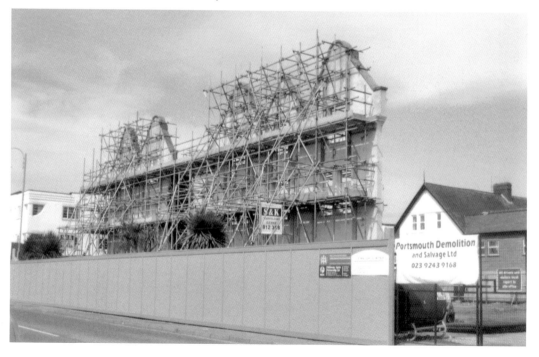

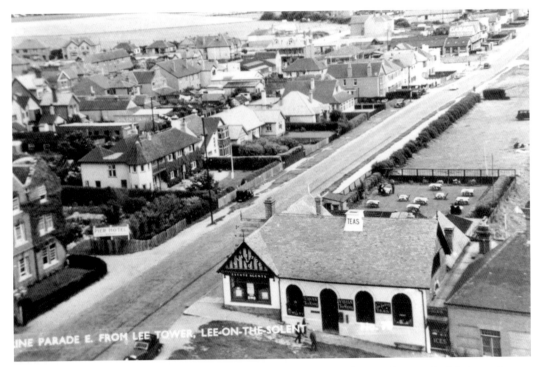

INE PARADE E. FROM LEE TOWER, LEE-ON-THE-SOLENT

Above and below: The completion of Lee Tower in 1935 not only provided wonderful views of the Solent and Isle of Wight, but by turning inland one also acquired a superb panoramic picture over Lee-on-the-Solent. Photographer Ethel Blakey took both of these pictures in the 1930s.

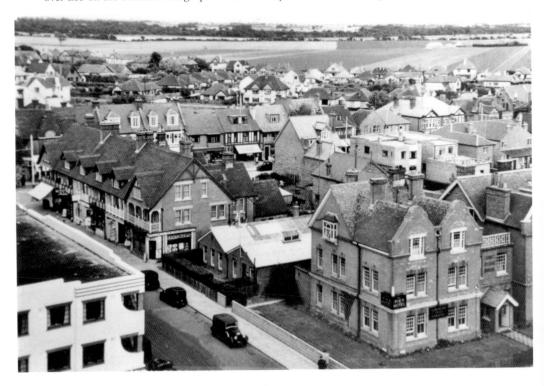

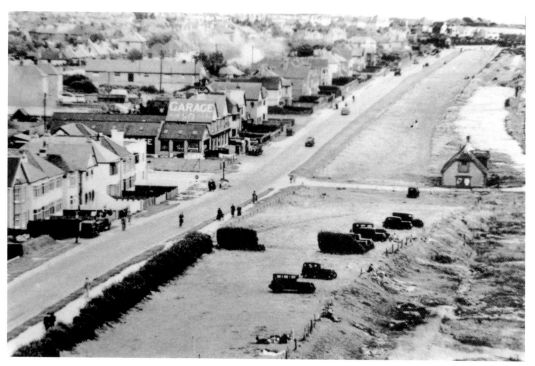

Above and below: Another Tower view, looking along Marine Parade East in the 1930s. Skipper's Garage can be seen on the corner of Beach Road. The lower picture provides a fine shot of Marine Parade West, showing Lee swimming pool on the shoreline.

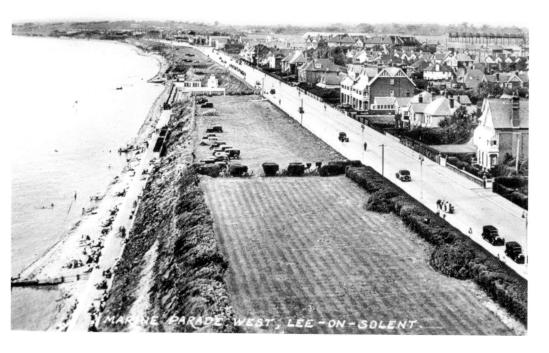

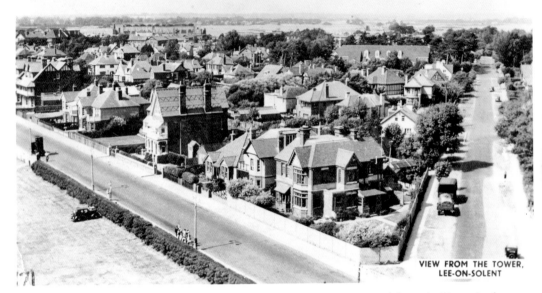

VIEW FROM THE TOWER,
LEE-ON-SOLENT

Above: The corner of Marine Parade West with Milvil Road as viewed from the Tower in the 1940s.

Below: An earlier view of the corner above from ground level. The large corner house has fallen to the demolition hammer and a block of seafront flats, West Point, was erected on the site.

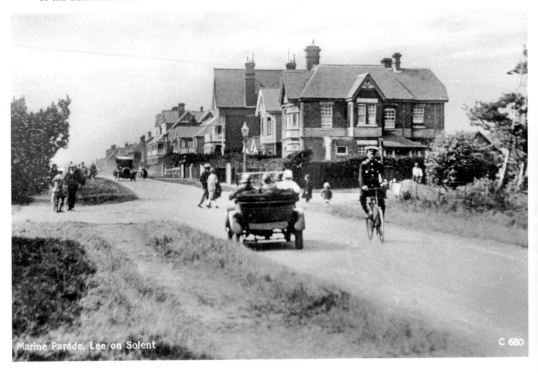

Marine Parade, Lee on Solent

C 680

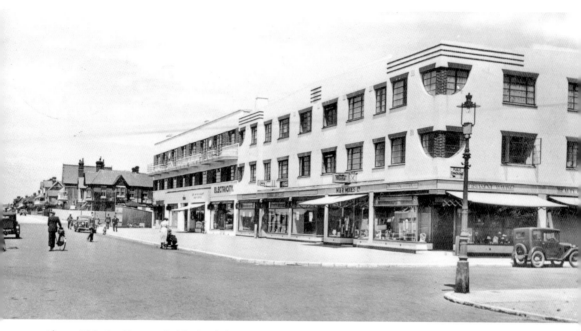

Above: This Art Deco-style block of shops and flats, Marine Court Mansions, was built in the mid-1930s to complement the new Lee Tower complex opposite and still dominates the seafront centre of Lee.

Below: Another 1930s view of the above with the war memorial in the foreground. When this photograph was taken, the Lee post office and Electricity Showroom were in this block.

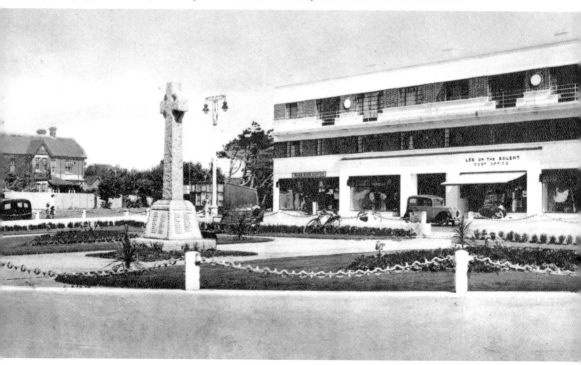

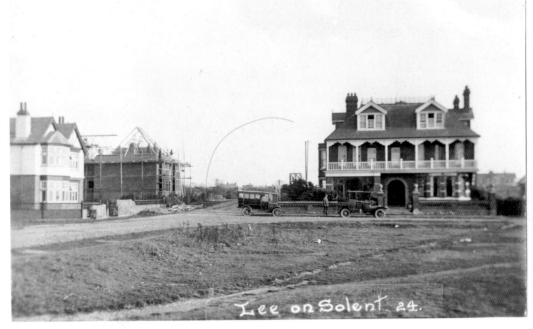

Above: This rare picture was taken at the eastern end of Lee High Street in the 1920s at the junction with Beach Road. The large house on the right is Heylands Court Hotel in Beach Road; the corner open ground in the foreground later housed Fletcher's Garage by the 1930s.

Below: Heylands Court Hotel in Beach Road, the site of which is now occupied by the Hometide House retirement flats.

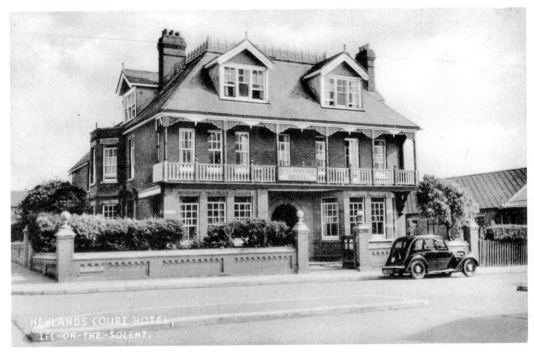

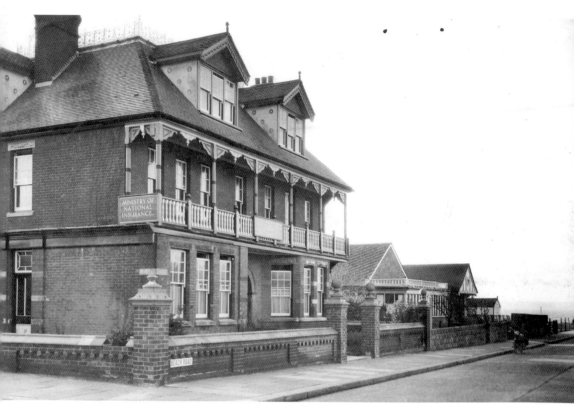

Above: In this later photograph of Beach Road from the High Street, the Heylands Court Hotel has been acquired by the Ministry of National Insurance.

Below: This photograph features the opening of Lee-on-the-Solent Library at the eastern end of the High Street in November 1937.

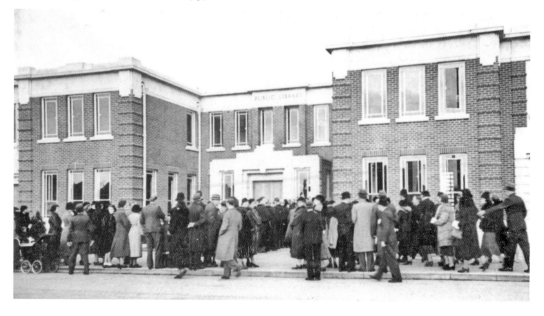

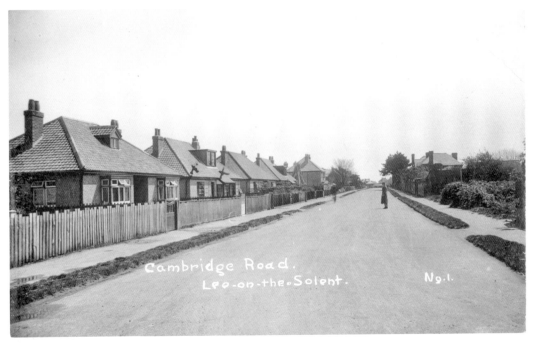

Above: Where have all the cars gone? Cambridge Road, Lee-on the-Solent, in about 1930 from the junction with the High Street.

Below: Gosport Road, Lee, in the late 1920s, when children could play safely in the streets. These kids probably attended Lee Council School, which was just around the corner, off Cambridge Road.

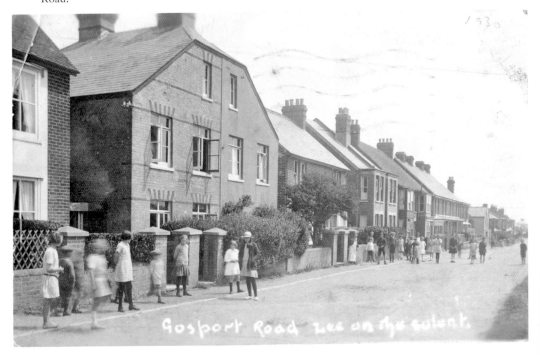

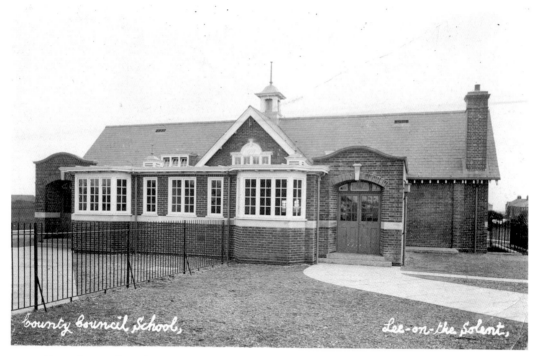

Above: Lee-on-the-Solent Council School in 1908, the year that it was erected to cater for 150 pupils.

Below: Lee Council School infants' class pose for a group photograph in 1914, at which time the popular Miss Elvey was the headmistress until her retirement in 1923.

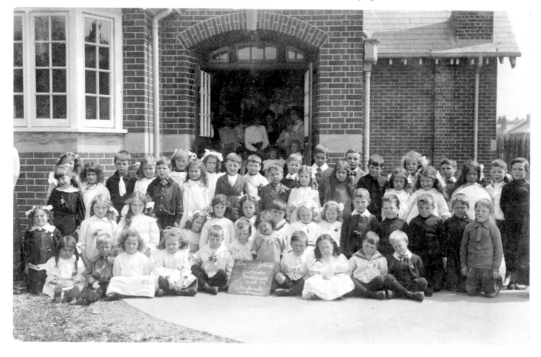

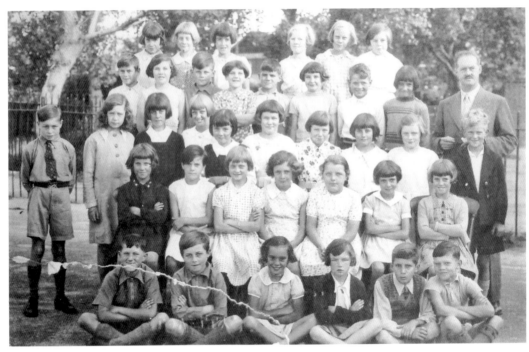

Above: Maurice Nixon was one of the most popular Lee School headmasters in the 1930s and 1940s; he is featured here posing for a group shot with Junior School pupils in 1936.

Below: Lee-on-the-Solent School reception class in 1952. The teacher on the left of this photograph is Mrs M. Barnicott (née Donohoe).

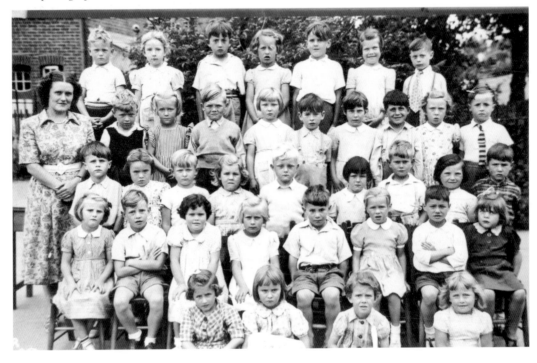

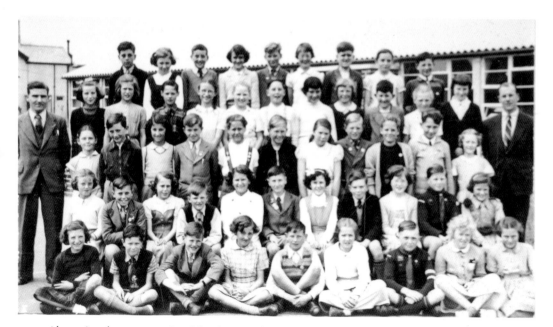

Above: Another post-war Lee School group photograph. This one was taken in 1954 and features the top class. The teacher on the left is headmaster Mr Fisher, while standing on the right is class teacher Mr Burton.

Below: The reception class of 1956 with teacher Mrs Barnicott at the left of the picture. The author admits to preferring the old black and white school photographs against the colour ones that are sold today – the faces appear so much clearer.

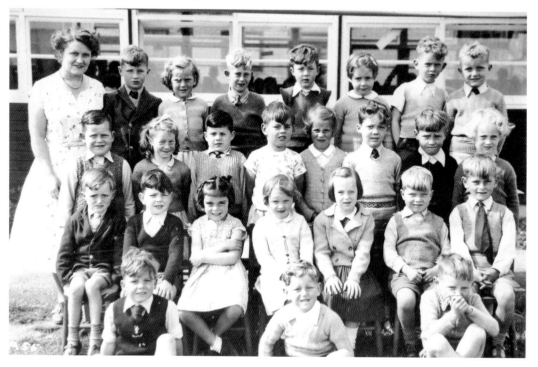

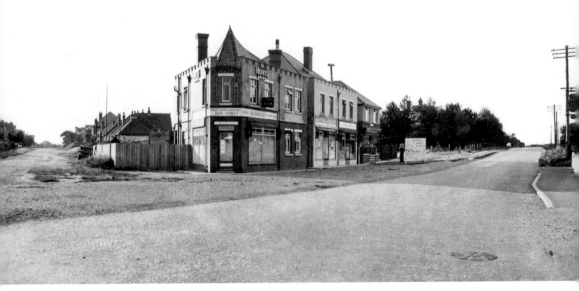

Above: Elmore, at the eastern end of Lee, from Portsmouth Road in the 1930s. An unmade Raynes Road is on the extreme left with a baker's shop on the corner in the centre of the photograph.

Below: This view was taken from the same spot in Portsmouth Road around the same period, but the photographer has turned his lens slightly to the right to take in the Inn by the Sea public house.

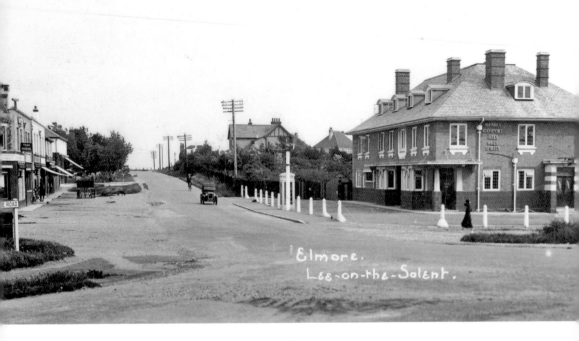

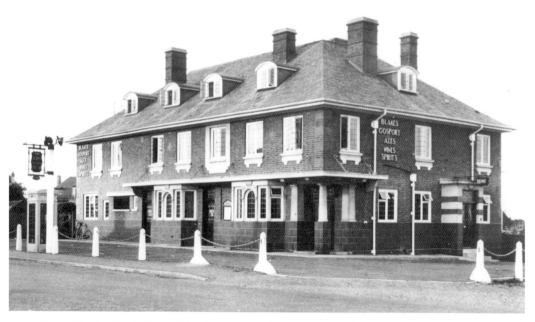

Above: The Inn by the Sea pub in the 1930s. In the times we now live in, pubs in the Solent area appear to close to make way for flats almost on a weekly basis, but thankfully this pub at Elmore is still open and flourishing.

Below: Reflecting the spirit of a good community pub, here we have a jolly Inn by the Sea men-only coach outing in the 1930s.

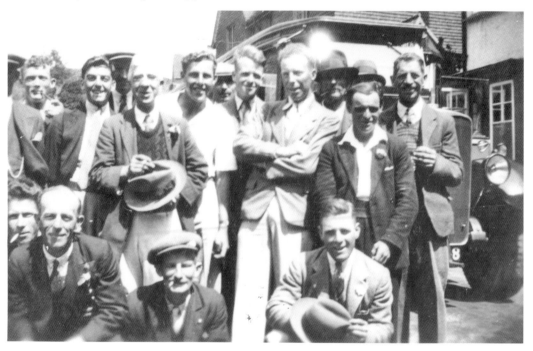

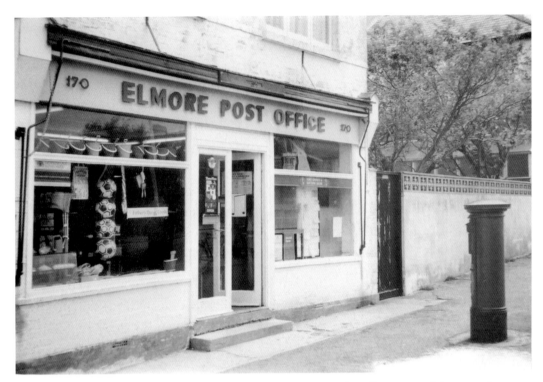

Above: Elmore post office in Portsmouth Road, Lee, in 1983. This office is one of the many that have been closed over the past twenty years or so, although some have been reinstated in small supermarkets and convenience stores.

Below: Portsmouth Road as viewed near the junction with York Crescent in the 1930s. Although the gaps between the properties have long since been developed, the houses on the right of the photograph are still recognisable.

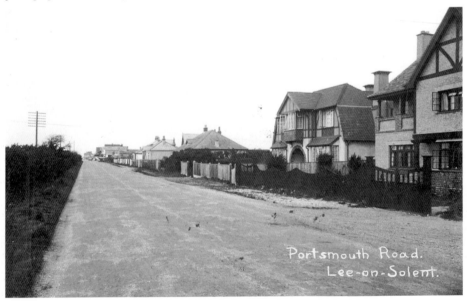

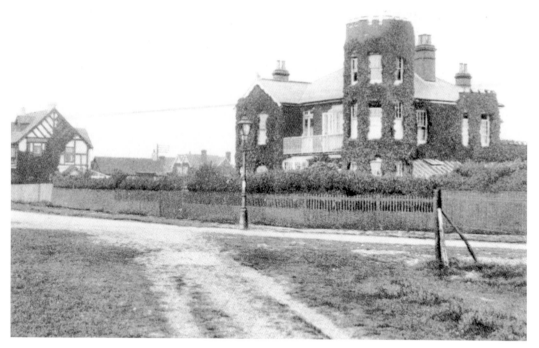

Above: This castle-style house was named The Towers and once stood at the junction of Marine Parade East and Portsmouth Road until it was demolished over thirty years ago and replaced by modern seafront flats.

Below: Captured in the early 1930s from Portsmouth Road, this viewcard is captioned as Chester Crescent.

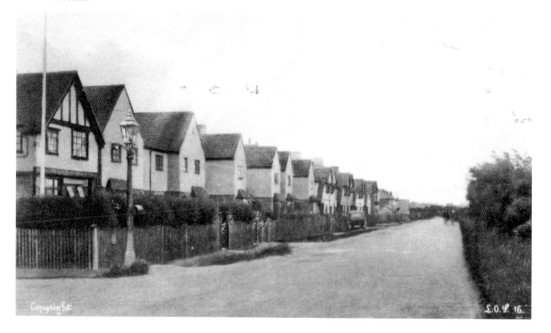

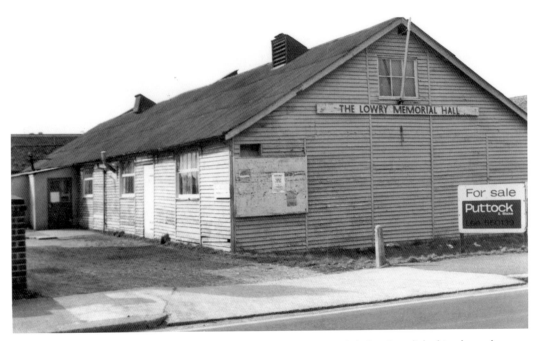

Above: The Lowry Memorial Hall in Lee High Street prior to it being demolished in the early 1980s. This hall was donated by the Lowry family in memory of the sons they lost in the Great War; it was formerly the old YMCA in Gomer Lane.

Below: Mansfield House on the corner of Milvil Road and Newton Place, which has served as a hotel and, after the war, as a home for the blind. During the Second World War it was a billet for Wrens.

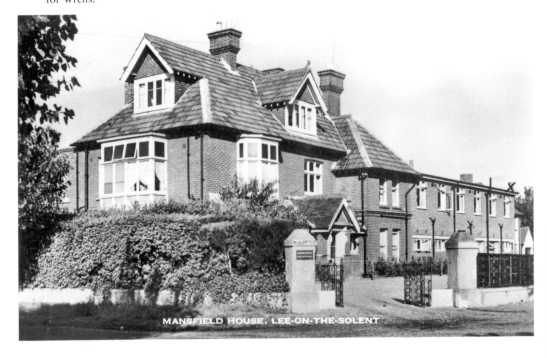

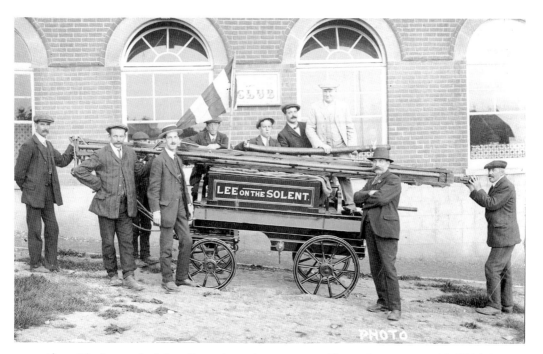

Above: The Lee-on-the-Solent fire tender and crew, *c.* 1910. The tender was garaged in Wright's builders' yard and Charlie Lawrence was the fire chief. In the 1920s and 1930s fires were dealt with by the RAF fire brigade.

Below: A Solent Dairy milkcart with female driver outside the Victoria Hotel in Manor Way. The proprietor of the dairy was William Smith.

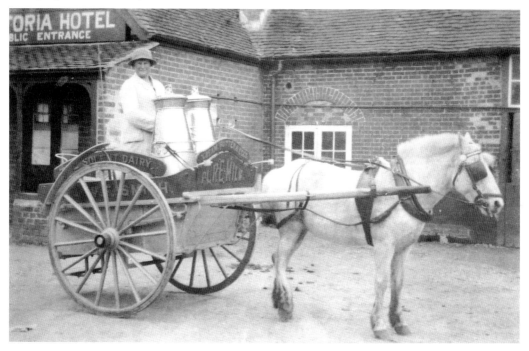

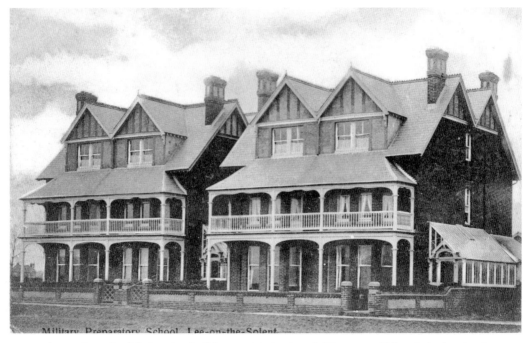

Military Preparatory School, Lee-on-the-Solent

Above: This splendid Victorian building on Marine Parade West can still be admired today. In this *c.* 1910 photograph it served as a Military Preparatory School, although in later years it was a children's home.

Below: Another photograph of the same building around the same period; sadly, the days when hay-making took place on the cliffs above the seashore are long gone.

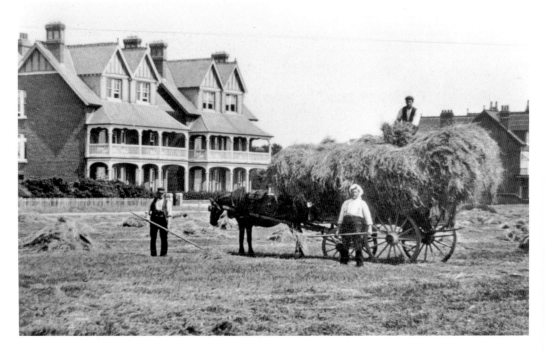

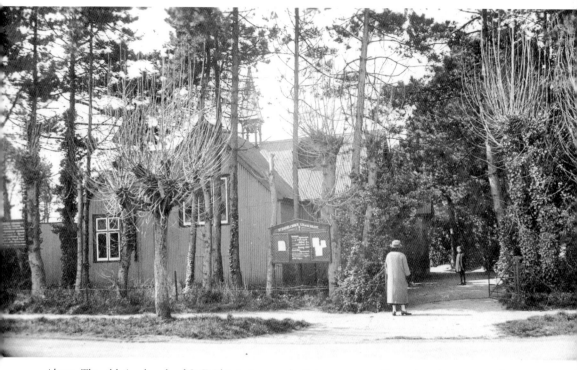

Above: The old tin church of St Faith's in Lee-on-the-Solent, *c.* 1930. Erected at the expense of Sir John Robinson, this church was only intended to be a temporary structure, but survived for over thirty years.

Below: The interior of the old tin church. At times of heavy rainfall on the tin roof, parishioners could hardly hear the vicar's sermon.

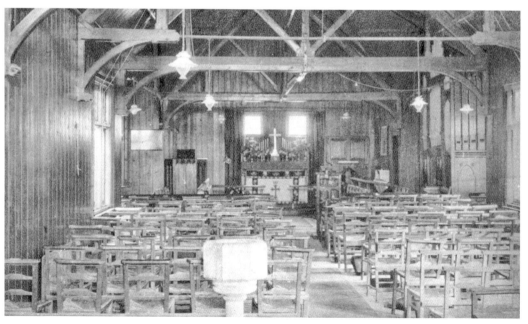

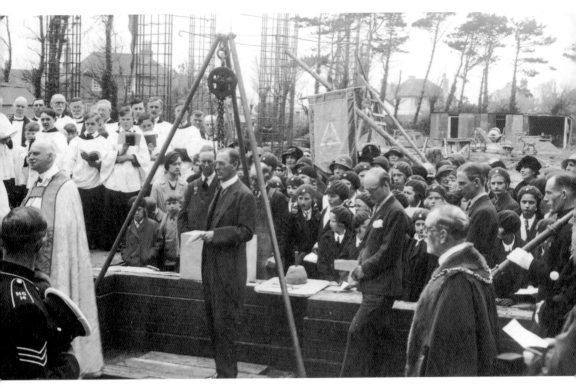

Above and below: The good folk of Lee had to wait until 1933 for a more permanent church; both these photographs were taken at the laying of the foundation stone on 16 May 1932, which was conducted by Bishop Neville Lovett.

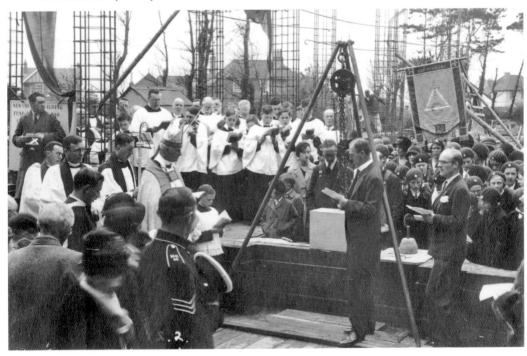

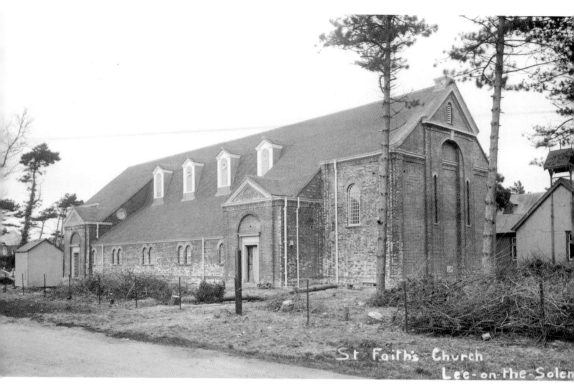

Above and below: The new St Faith's church, built to seat 400 people, almost complete in 1933; in the top photograph one can still see the old tin church awaiting its removal. The first vicar of the new church was the Revd Douglas Hunter and the vicarage was in Richmond Road. St Faith's still flourishes in Victoria Square.

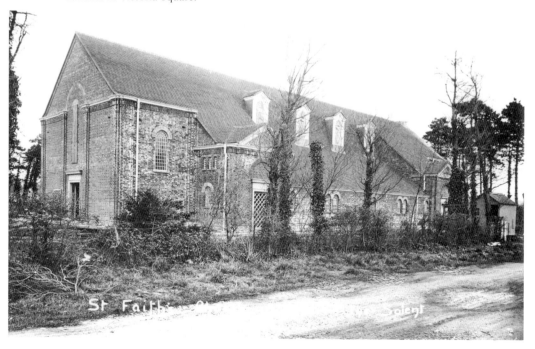

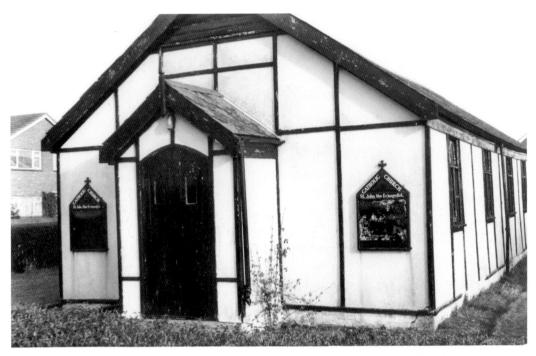

Above: The Roman Catholic Church of St John the Evangelist on the corner of South Place and Clifton Road in 1979.

Below: A baptism in the Solent at Lee in 1928; a large crowd gathered to witness thirty men and women baptised in the sea under the Four Square Gospel Testimony. White gowns were worn over swimming costumes.

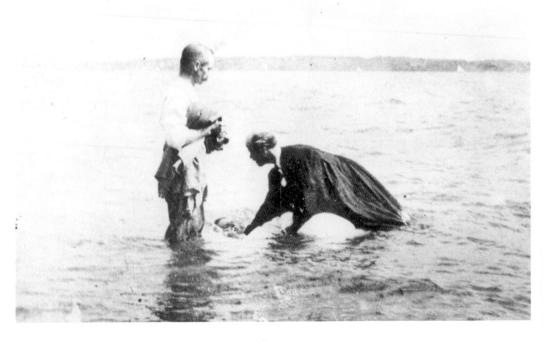

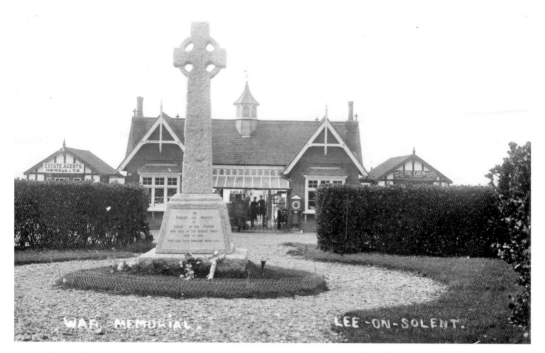

Above: Erected to commemorate the men of Lee lost in the Great War, this 1920s war memorial stood at the entrance to the pier. This stone can still be seen on the seafront, but in a slightly different location, next to a car park.

Below: The existing Second World War naval memorial on Marine Parade West. The impressive HMS *Daedalus* wardroom block is in the background, believed to have been designed by Sir Edwin Lutyens.

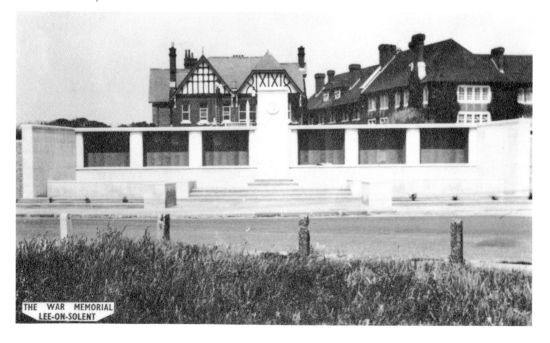

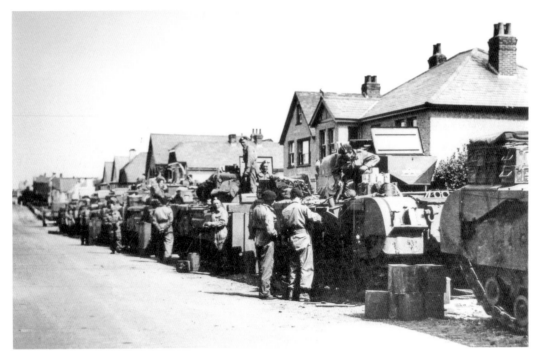

Above and below: During the Second World War, although Lee did not suffer the extensive bomb damage inflicted on Portsmouth and Southampton, or even neighbouring Gosport, it survived to play an important role in the D-Day invasion of June 1944. These wartime photographs show tanks and military vehicles being prepared for embarkation.

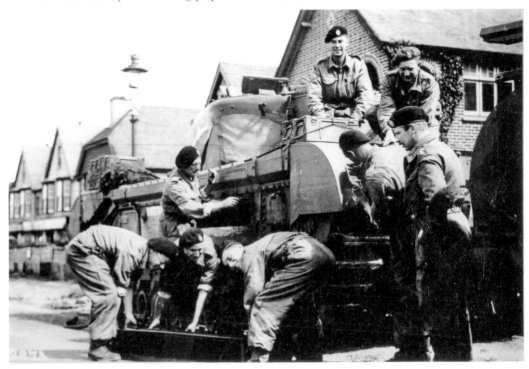

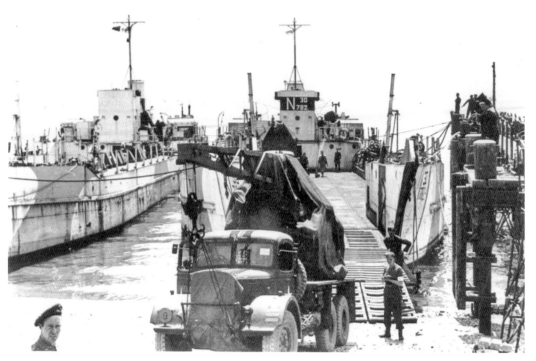

Above: The Royal Engineers embarking a mobile crane at the Lee-on-the-Solent slipway, June 1944.

Below: Cheerful men of the Royal Engineers pose with their mascot before boarding a landing craft to sail over to Normandy from Lee. We may hope that this doggie brought them good luck and a safe return.

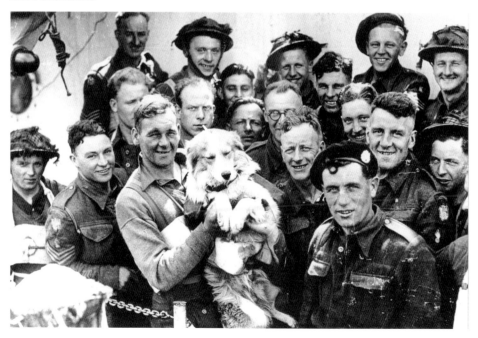

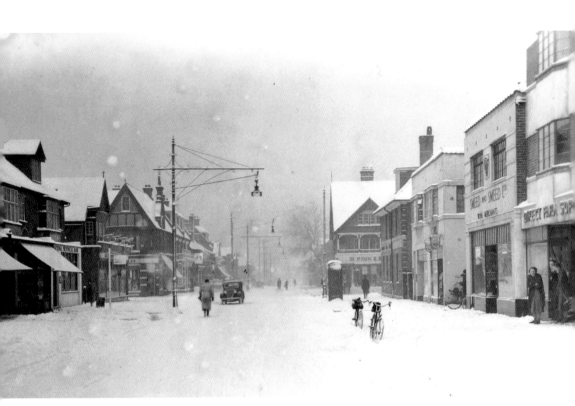

Above and below: 'Dreaming of a White Christmas'. That dream certainly came true in the winter of 1938, as confirmed in the top picture of Lee High Street. The lower shot was taken in a snow-covered Manor Way.

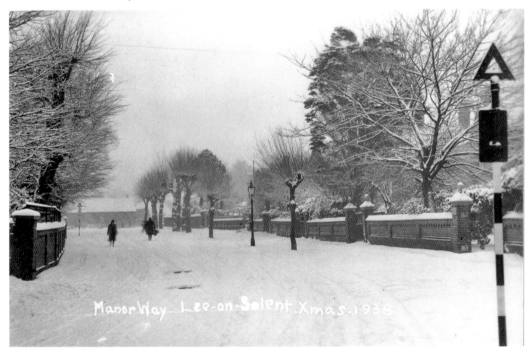

two

A Pier of Pleasure

In the late nineteenth and early twentieth centuries, no seaside resort could claim to be such if it did not have a pleasure pier. Lee-on-the-Solent was no exception and in line with the Robinson family's ambitious plans, a pier was indeed erected and officially opened for public pleasure on 3 April 1888. With a length of 750 feet, although not in the class of Brighton, Blackpool or Southend, Lee pier was longer than neighbouring piers at Swanage, Boscombe and Southsea. With a superstructure of wrought iron braced together by diagonal transverse ties and a foundation of cast-iron screw piles, there was little doubt that this robust structure would carry the weight of large numbers of trippers and visitors on its impressive decking. It was another structural triumph for pier engineers Galbraith & Church, but history decreed that the venture's fortunes would be mixed.

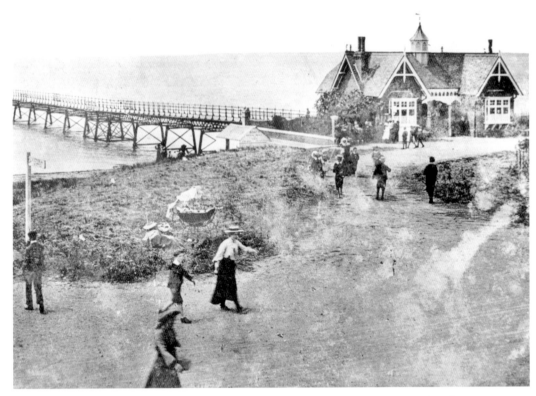

Above and below: From the first day of its opening in 1888, Lee pier proved to be a great attraction and the number of visitors increased steadily to allow Lee to take on the air of an up-and-coming seaside resort. The upper picture depicts the pier in the late Victorian or early Edwardian period; the lower was taken later, in 1914.

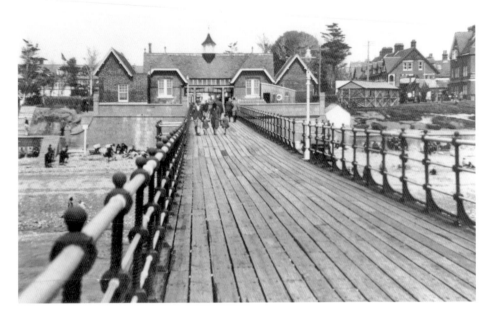

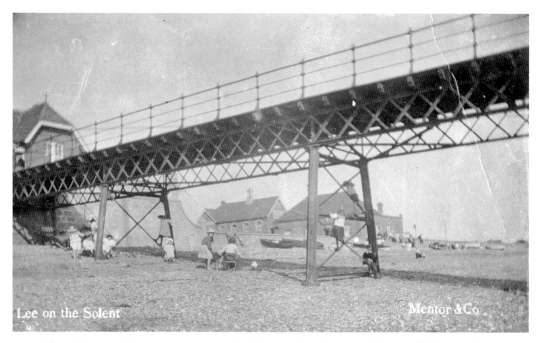

Above: Not exactly an exciting viewcard of the pier, but this 1905 photograph does emphasise the aforementioned solid metal construction that formed this Solent edifice.

Below: From a width of 15 feet, the pier broadened out at the end to 34 feet in order to accommodate a picturesque pavilion and a bandstand.

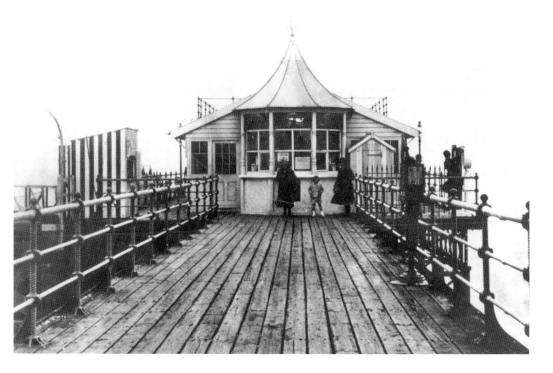

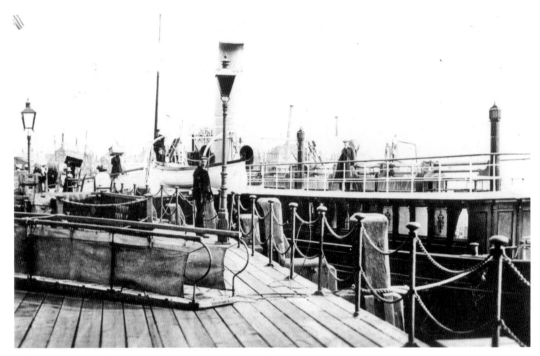

Not only was Lee pier invaded by visitors from the land end, but also from the sea end via steamers bringing hordes of trippers. The very first steamer to land passengers here on the first day of the pier opening was the *Princess Beatrice*, seen above. Trippers also crossed the Solent from Southampton, Cowes and Southsea; below we see a steamer leaving Clarence Pier.

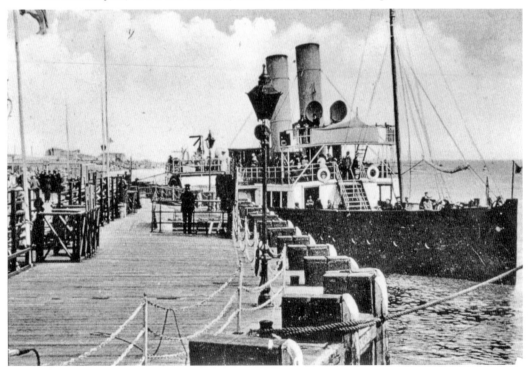

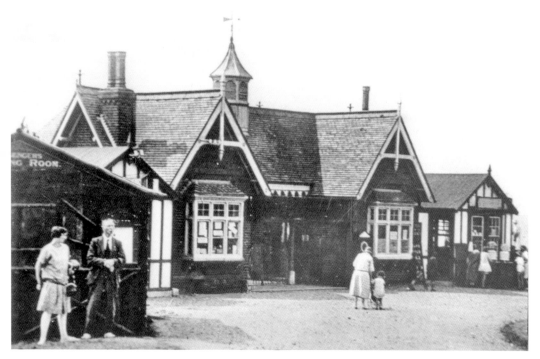

Above: The quaint entrance building to the pier where one purchased an admission ticket to stroll down the pier, to board a steamer, or perhaps fish from the end.

Below: The entrance gates to Lee pier; judging by the straw hats, this nostalgic photograph must have been taken in the summer. The posters by the gate advertise a Pierrot show in the end of pier pavilion.

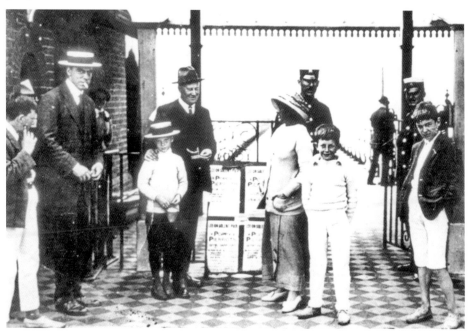

Above: If someone builds a pier, we can be sure that someone will provide a concert party; here we have the Joy Bells company of artistes, who were very popular entertainers on Lee pier in the 1920s and 1930s.

Below: In contrast to the sunseeking beach-goers of today, the Edwardians dressed up to go on the beach, as shown in this pier and shoreline view taken at Lee.

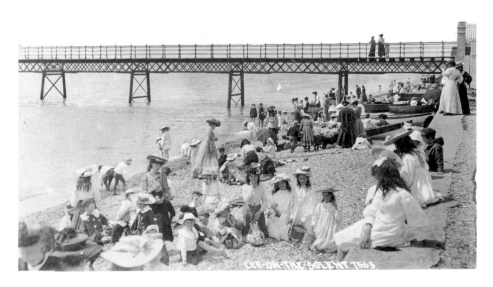

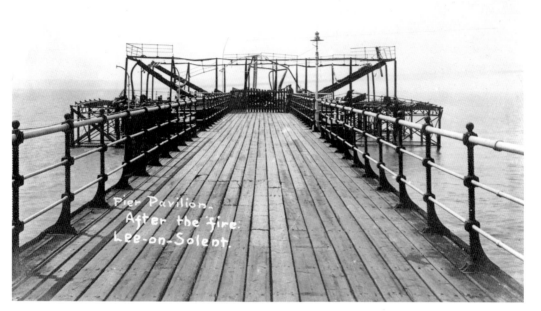

Above: A sad sight indeed – the pavilion at the end of Lee pier destroyed by fire in the late 1920s. Unfortunately, history has shown that pleasure piers are prone to fire, nearby South Parade Pier at Southsea being a prime example.

Below: Thankfully, from the ashes of the above rose a new pavilion that became known as the Golden Hall, seen here at the end of the pier.

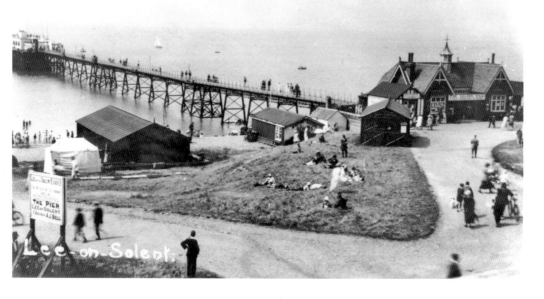

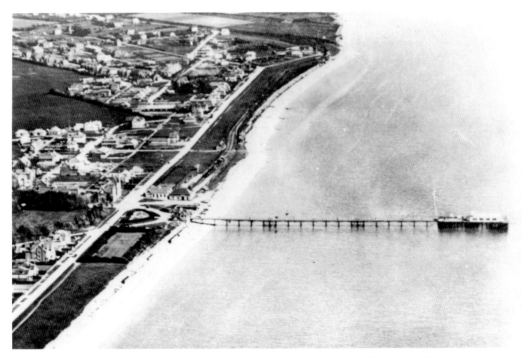

Above: A fine aerial shot of Lee pier captured prior to 1935, when the area leading to the pier entrance was developed and modernised considerably to allow Lee to compete with other coastal resorts.

Below: Here we see the wonderfully nostalgic interior of the pier ballroom, where dancers could trip the light fantastic to the music of some of the top bands of the day.

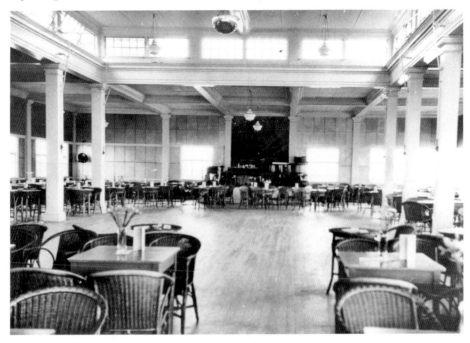

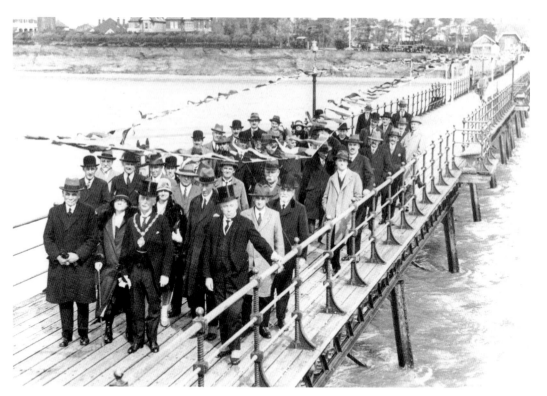

In 1930 the Borough of Gosport extended its boundaries to incorporate Lee-on-the-Solent and Rowner; here we see the Mayor of Gosport, Ben Kent, and a party of civic dignitaries on Lee pier and the seafront, inspecting their new domain. In 1946, Gosport had plans to extend westwards to take over Crofton and Hillhead, but the plan failed and Fareham Borough has retained control.

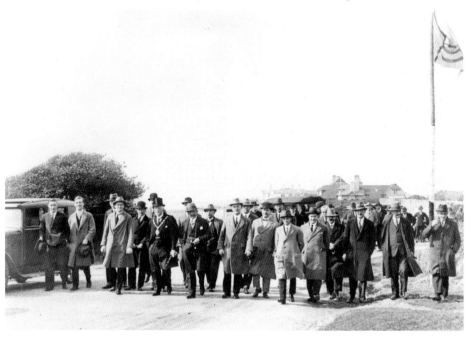

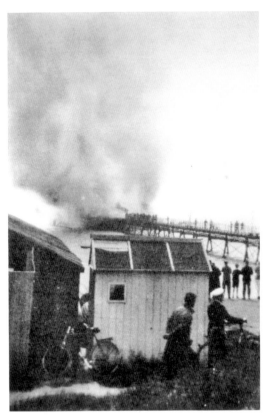

Left and below: On 19 June 1932, disaster struck Lee pier when fire destroyed the Golden Hall at the end. Piermaster Arthur Bradley and his staff managed to escape the fierce blaze, although the resident Harry Lawrence Dance Band lost all their instruments, which were stored there. Sadly, the pavilion was not rebuilt, and during the Second World War the pier was breached to repel enemy invasion, but not restored after the war. Lee therefore lost one of its once-popular attractions and today there is no sign that a pier ever existed.

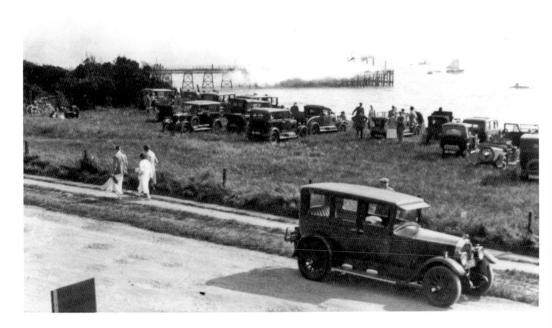

three

Making Tracks for Lee

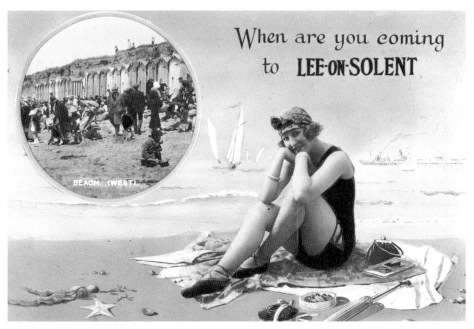

When are you coming
to **LEE-ON-SOLENT**

BEACH. (WEST)

From its inception in the late 1800s, it was essential that an expanding resort such as Lee should have good transport links to help visitors to reach its coastal location. So, it was with great hopes for the future that the Solent Light Railway began running in the May of 1894. Passengers travelling to Lee disembarked from the L&SWR line at Fort Brockhurst between Fareham and Gosport to board the Lee train. Although only covering a total distance of three miles to the terminal station on Lee front, running partly through country and beside the sparkling waters of the Solent, it was one of the prettiest and most spectacular rail routes in Britain. The line had several small halts in the form of Gomer Halt (later Privett Halt), Browndown Halt and Elmore Halt. It was operated by a private company until 1909, when it was taken over by the L&SWR until 1923, when it ran under the Southern Railway banner until it closed to passenger traffic in 1930, although it still operated for goods only until 1935.

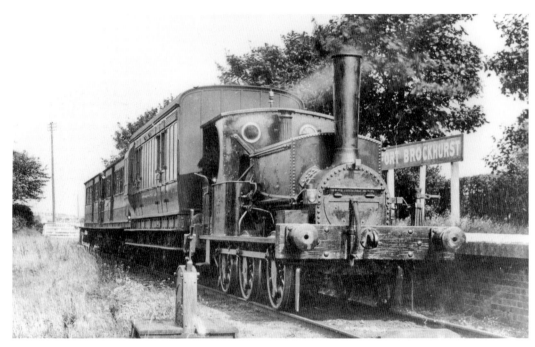

Above: A Terrier tank engine waits at Fort Brockhurst station to pick up rail passengers wishing to travel on to Lee-on-the-Solent rather than continue down to Gosport.

Below: Brockhurst station staff, *c.* 1900. At this time the stationmaster was William Bew, who served at Brockhurst for twenty-six years until his retirement in 1926. Most of the railway staff attached to the Brockhurst–Lee line doubled up on their duties.

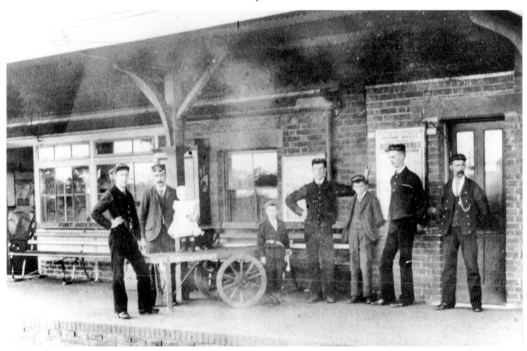

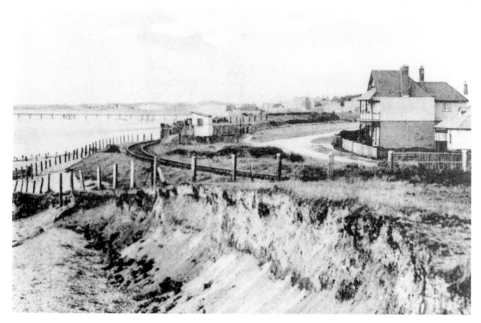

Above: A postcard view taken *c.* 1920 at the east end of Lee, showing the bend in the railway line where the Elmore Halt stop was sited. This halt was just a single platform with a shed-style passenger waiting room.

Below: A later, post-war photograph of the bend in Marine Parade East, taken twenty years or so after the railway service had ceased and the lines had been removed. One single car is visible, but some sixty years on this has become a busy road linking Gosport to Lee and beyond, travelling west.

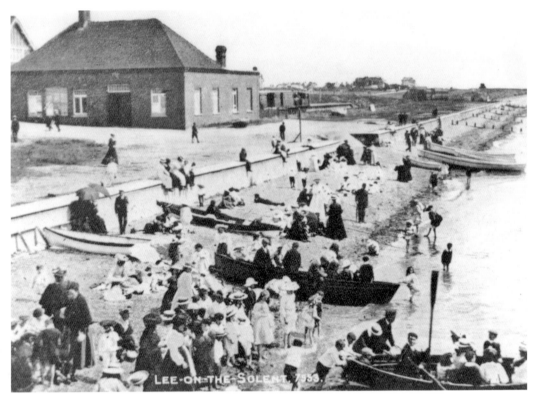

Above: Journey's end – the railway station alongside the seafront at Lee. Visitors alighting here could virtually step out onto the beach. This view was captured around 1908.

Below: A train waiting for passengers travelling to Fort Brockhurst to change trains for Gosport, or perhaps London.

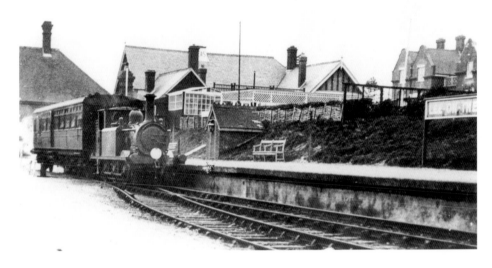

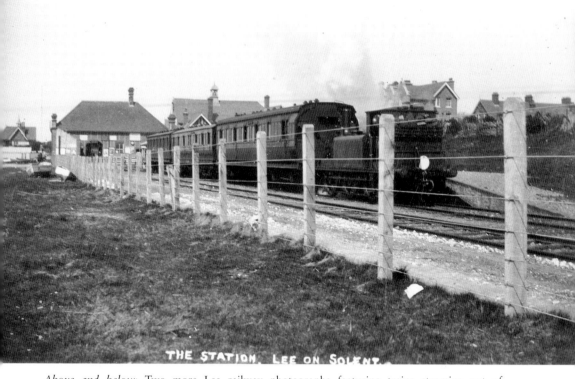

THE STATION, LEE ON SOLENT

Above and below: Two more Lee railway photographs featuring trains steaming out of the terminal station. Not only was this picturesque rail service popular with trippers and holidaymakers, but the stop at Browndown Halt was also convenient for territorial army units based at Browndown summer camp.

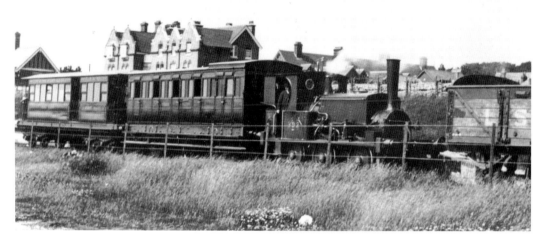

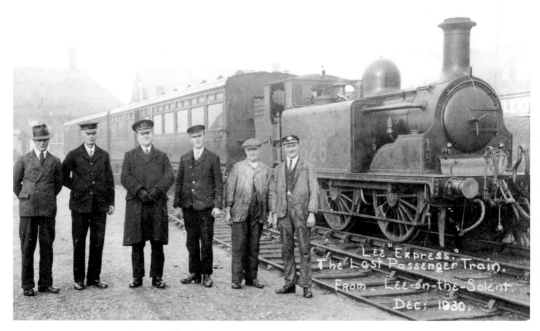

Lee "Express."
The Last Passenger Train.
From Lee-on-the-Solent
Dec: 1930.

Above: A sad occasion – railway staff pose in front of the last passenger train to leave Lee station in the December of 1930. Mr Marlow was the last stationmaster; at times he also served as booking clerk, porter and ticket collector. A goods train service continued until 1935.

Below: Remarkably, the old station building has survived the years and still houses the Olympia Amusement Arcade, as it has done for many decades. This photograph was taken in 2010.

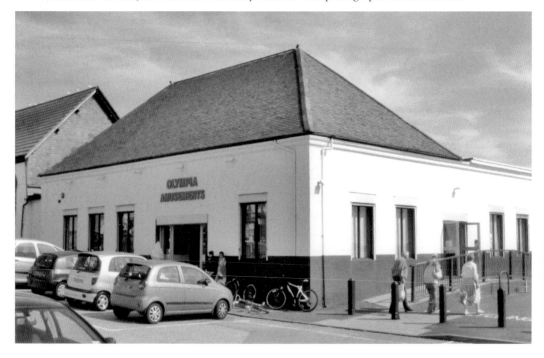

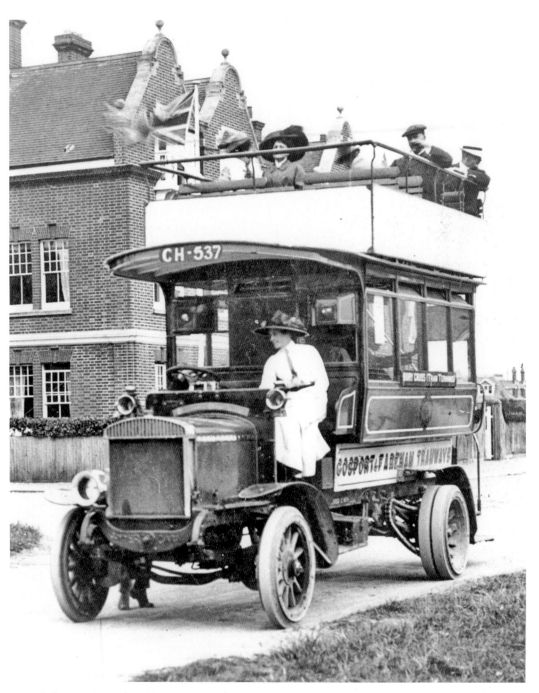

A Gosport & Fareham Tramways omnibus waiting outside the Pier Hotel at Marine Parade. After electric trams were introduced in Gosport in 1906, it was originally intended to extend the line to Lee; however, the service terminated at Bury Cross, so a bus service operated for passengers wishing to travel on to Lee.

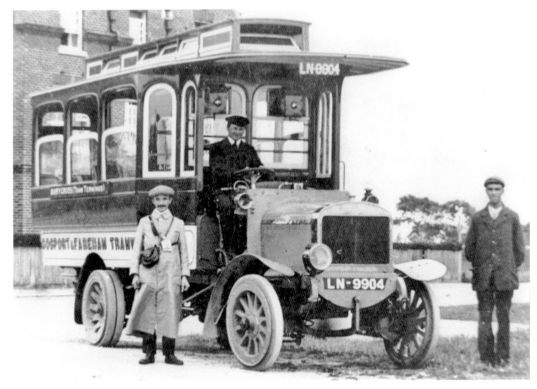

Above: Another photograph taken at the Pier House terminus in 1916 with a Tramways bus waiting to transport passengers to Gosport via Browndown and Gomer.

Below: 'The Last Car from Lee-on-the-Solent'. Humorous cards like this were published for most seaside resorts around the country, the place name being changed accordingly.

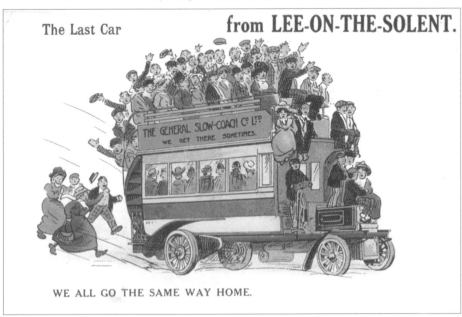

Yellow Conveyances

SMITH'S GARAGES

(OPPOSITE THE FERRY)

137

MOTOR BUS SERVICE

—— BETWEEN ——

Gosport and Lee-on-the-Solent, Gomer and Browndown.

TIME TABLE.

Leaving Smith's Garage	FARES—TO LEE	Leaving Lee
8.30		9.0
10.0 *9 - 0*	**Lee** - 1/-	11.0 *10 - 0*
11.30	(1/6 Return)	12.0
12.0		1.0
1.0	**Avenue** - 3d.	2.0
2.0	**Gomer** - 6d.	3.0
3.0		4.0
4.0	**Elmore** - 9d.	5.0
5.0		6.0
6.0	FARES—FROM LEE	7.0
7.0		8.0
8.0 *9 -0*	**Elmore** - 3d.	9.0 *10 - 0*
10.0		10.30
SUNDAYS	**Gomer** - 6d.	**SUNDAYS**
12.30	**Avenue** - 9d.	1 o'clock
and continue.		and continue
SPECIAL	**Hard** - 1/-	**SPECIAL**
11 o'clock Bus	(1/6 Return)	11 o'clock Bus
Saturday Nights		Saturday Nights

LATE THEATRE SERVICE.—Providing sufficient names are handed in at the Offices, a later Bus will run after the Theatres.

Parties specially arranged for other occasions.

Prior to being taken over by the big transport concerns such as Provincial, Southdown and Hants & Dorset, a number of private bus companies flourished locally into the 1940s. Hubert Smith's fleet of buses, known as the 'Yellow Motor Service', operated a route between Gosport and Lee-on-the-Solent in the inter-war years, but because of the terrible potholes on the route it was often a case of 'Hold on to your hats!'

Above: George Skipper's Garage on the corner of Marine Parade East and Beach Road. This site now houses a block of flats, Solent Heights. George's wife, Gladys Skipper, served Lee as a councillor on Gosport Council.

Below: Interesting vehicle line-up by W. & B. Transport of Lee-on-the Solent in the 1920s.

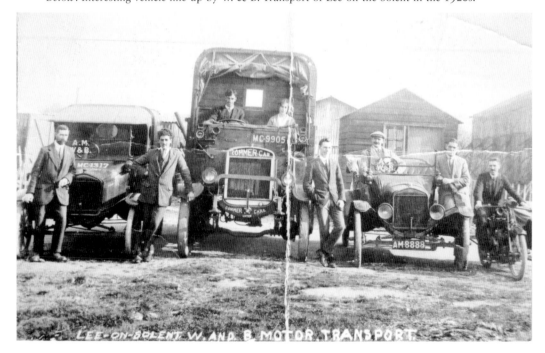

four

It's in the Air

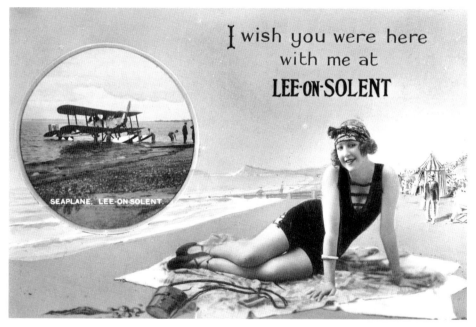

Lee-on-the-Solent played an important role in British aviation history spanning over eighty years. It began in the First World War when the Admiralty decided that seaplanes were the ideal craft for aerial spotting in order to combat the German U-Boat menace and subsequently carried out trials from a slipway at Lee in 1915. A naval seaplane base and training school was set up in 1917 and was controlled by the Royal Naval Air Service and the Royal Air Force until 1939, when, under the wing of the Fleet Air Arm, the base at Lee became HMS *Daedalus*, performing sterling work during the Second World War. The name, *Daedalus*, was derived from Greek legend, although for six years between 1959 and 1965 it operated as HMS *Ariel* before reverting back to HMS *Daedalus*. Over the following years the base gradually lost its importance as an airfield and subsequently closed in 1996. Since then there has been much conjecture about the site's future use and development.

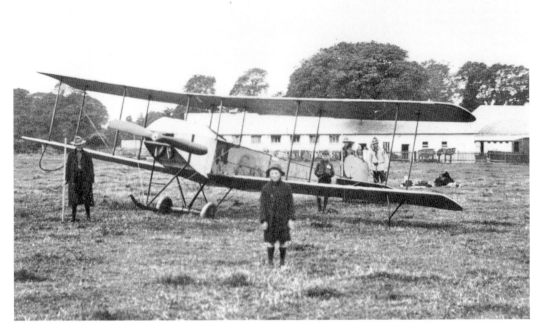

Above: When this Army biplane landed at Court Barn Farm in 1912, it created quite a sensation among the good folk of Lee, but within a few years aircraft overhead and on the ground would become an everyday experience.

Below: This early aerial photograph features the air station at Lee-on-the-Solent, as viewed from the Solent.

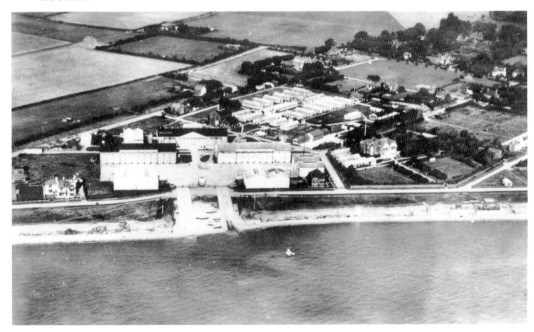

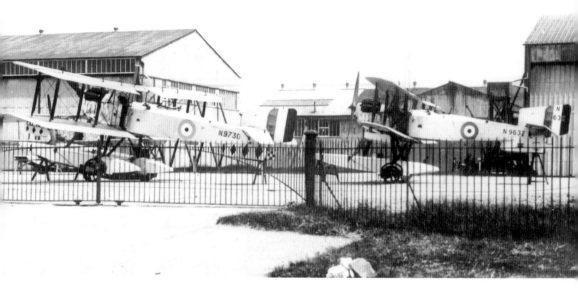

Above: A 1920s view of the south entrance to the airbase from the slipway with Fairey IIID seaplanes displayed prominently.

Below: RAF men assisting seaplane K8462 out of the Solent. When they were later replaced with improved floats, the old square-box floats became redundant and were sold to the public to be used as boats.

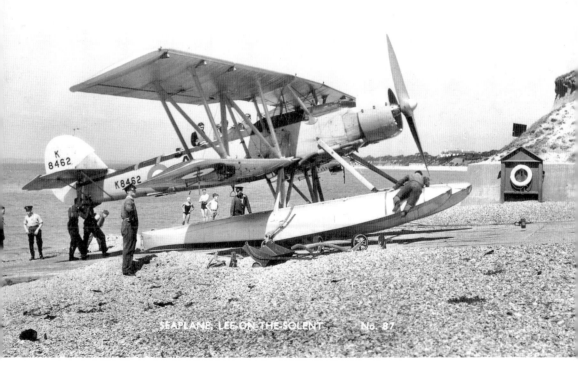

SEAPLANE, LEE-ON-THE-SOLENT No. 87

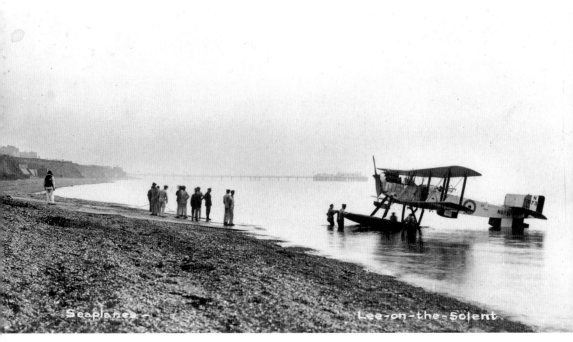

Above and below: Two more historic photographs of seaplanes by the beach at Lee in the 1920s. Many excellent local aviation pictures were captured through the lens of photographer Ethel Blakey, who after learning her trade in London came down to settle in Lee and open a studio in the High Street.

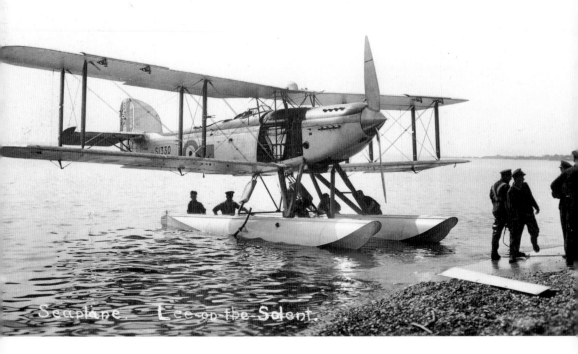

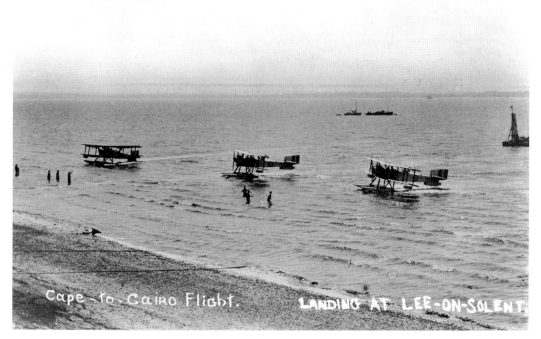

Above: Photographer Miss Blakey was on hand to record the arrival of the Cape-to-Cairo Flight on 21 June 1926. Wing Commander Pulford and five other officers flew four Fairey IIID biplanes from Cairo to the Cape, then back to Cairo and ultimately to Lee.

Below: A Fairey IIID seaplane with a 450-hp Napier Lion engine being hauled ashore at Lee.

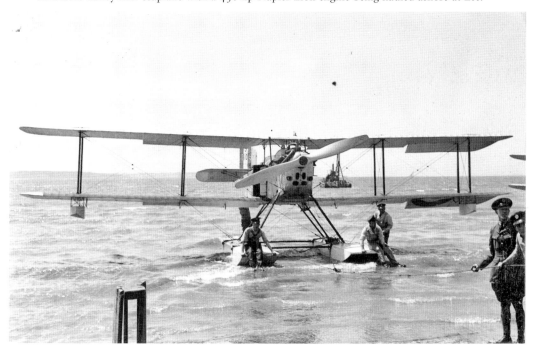

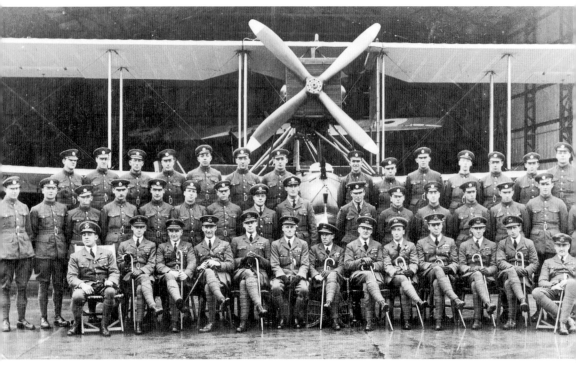

Above and below: Two RAF group photographs taken at Lee-on-the-Solent air base in the 1920s. The top picture is the No. 440 Seagull Flight, dated December 1923. The lower picture was also posed in December, but later in the 1920s. Around 1932, the air station became the HQ of the newly formed Coastal Command and the airfield acquired new runways and hangars.

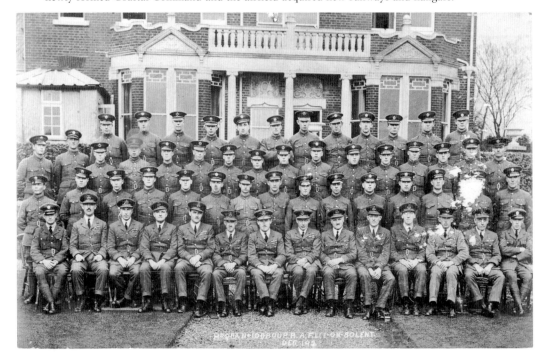

Right: 'Fiddlin' and Foolin" at Lee airbase in the 1920s. Armed with brushes and brooms, these RAF men cheerfully pose for a postcard picture to send home to their loved ones.

Below: The western shore at Lee showing the hangars on the right and a seaplane being hauled onto the slipway to the left of the picture.

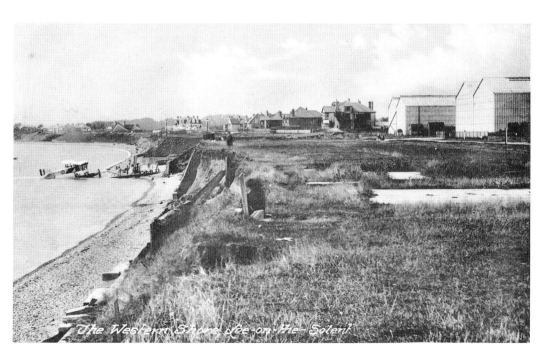

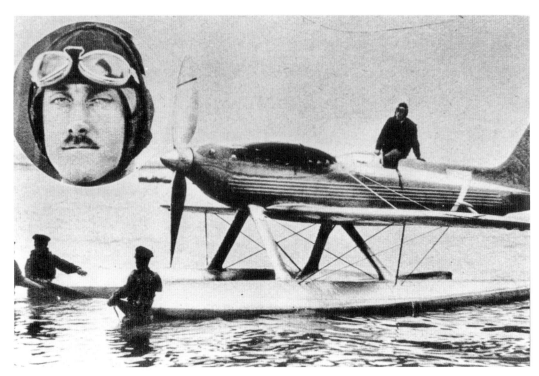

Above: In 1929 and 1931, the Lee shoreline provided a grandstand view over the Solent of the Schneider Trophy seaplane races. Flt Lt Stainforth (inset) won the 1931 event.

Below: Sir Alan Cobham, pictured with his team of flyers, brought his famous 'Flying Circus' to the Lee air show in 1935, and those adventurous enough could embark on a flight over the Solent in a Cobham plane.

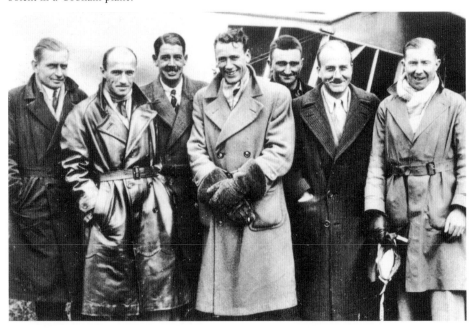

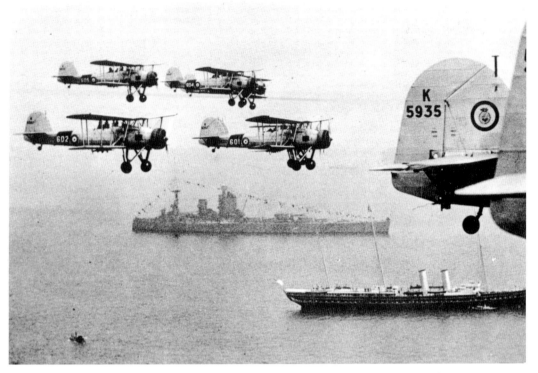

Above and below: Fairey Swordfish fly over the Royal Yacht *Victoria & Albert*, during the 1937 Coronation Fleet Review at Spithead. In the lower photograph they are flying over the aircraft carrier HMS *Ark Royal*, which joined the fleet in 1938 but was sunk by enemy torpedoes off Gibraltar in 1941.

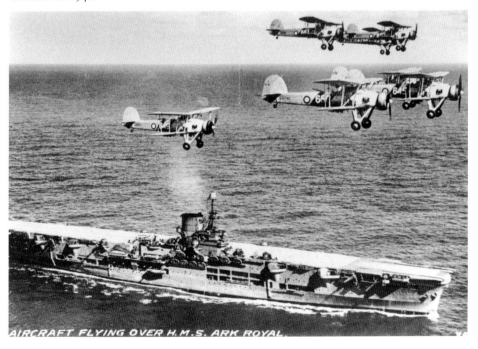

AIRCRAFT FLYING OVER H.M.S. ARK ROYAL.

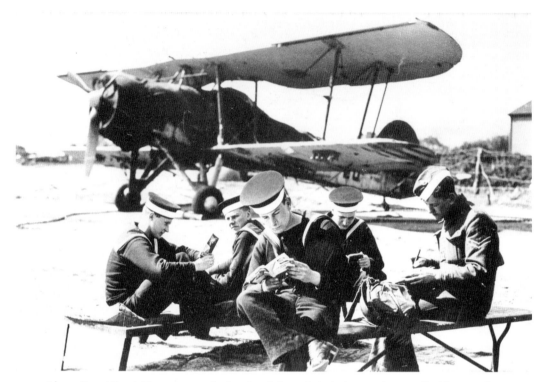

Above: 'Stand Easy'. Navy personnel take a break from their duties to enjoy a spell of fine weather, but the storm clouds of war were upon us and such breaks became fewer at Lee airfield.

Below: Officers and cadets of an ATC Squadron from Ryde, Isle of Wight, pose before a Blackburn Shark plane on a visit to Lee in 1942.

Above and below: Early on in the Second World War, in 1940, the Fleet Air Arm at HMS *Daedalus* had a surprise royal visitor when King George VI came to Lee-on-the-Solent. In the top picture he is chatting to a couple of pilots, while in the lower photograph he is inspecting Wrens attached to the base.

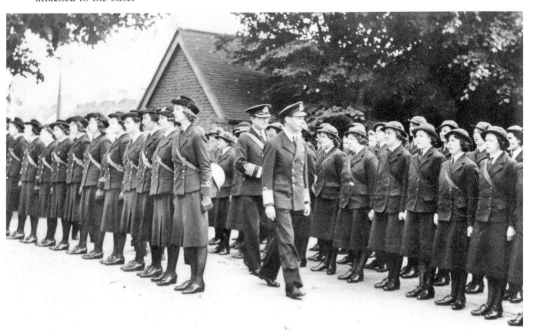

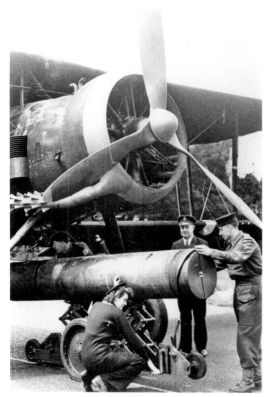

Left: Loading a Fairey Swordfish with a mine at Lee airfield in May 1943. The Swordfish still has an affectionate association with *Daedalus*, for it was one of the unsung heroes of the Second World War, being involved in the strategic attack on the Italian port of Taranto and torpedo strikes on the German battleship *Bismarck*.

Below: 'That is some baby in that pram!' A torpedo being transported for loading at *Daedalus* in 1942.

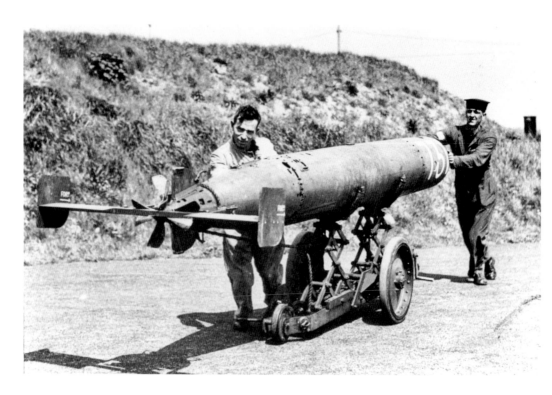

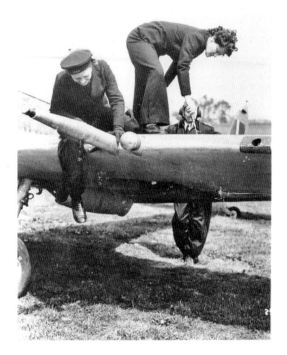

Right: Wrens carrying out maintenance work on a Seafire fighter plane at Lee in 1943. These ladies did sterling work in the war, so it was sad when eight Wrens were killed on 16 August 1940 when a bomb fell on their billet at Mansfield House. They were buried at Haslar Cemetery.

Below: A Fairey Barracuda plane at Lee airfield in 1943. In the German bombing raid of 16 August 1940, three hangars were destroyed and six aircraft were burnt out.

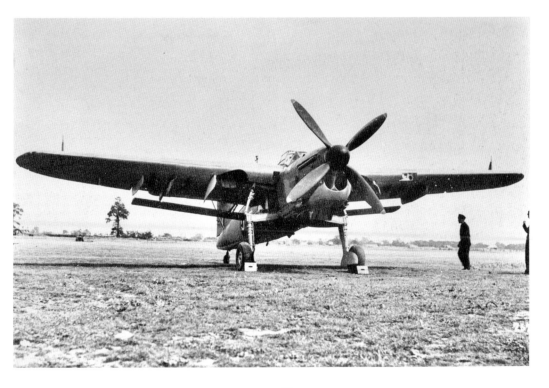

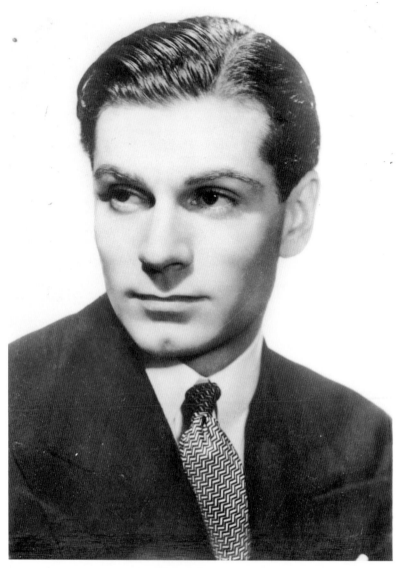

Actor-knights Sir Laurence Olivier (above) and Sir Ralph Richardson served in the Fleet Air Arm during the Second World War, and both great thespians were stationed at HMS *Daedalus*, Richardson attaining the rank of Lieutenant Commander and Olivier that of a Lieutenant Pilot. Laurence Olivier in particular was no stranger to Lee-on-the-Solent, for in 1932 he came here to film location shots for the film *Perfect Understanding* with his legendary Hollywood co-star Gloria Swanson. Swanson, who at thirty-five was ten years older than Olivier, co-produced the film and played the role of an American woman on holiday in this country who meets and falls in love with a British aristocrat, Olivier, and they subsequently marry. Sad to say, the film was a box-office flop!

Above: HMS *Daedalus* pay-office staff in 1943. This group photograph was taken at Ingleside Cottage, Hillhead, where their office was conveniently situated next to the Osborne View pub.

Below: At the end of hostilities, *Daedalus* returned to normal operations and the first Fleet Air Arm Field Gun Crew was set up at the base in 1947 to compete with other services at the Royal Tournament in London, a tough event for tough men. This action picture was captured at *Daedalus* in 1980.

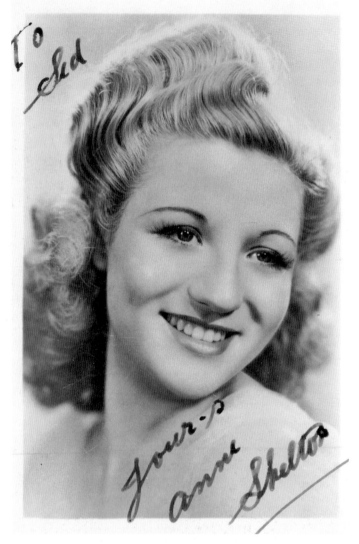

To Sid

Yours Anne Shelton

Air events open to the public were presented at Lee Airfield in the 1930s, notably the aforementioned visit of Alan Cobham's 'Flying Circus' in 1935, but it was in the post-war years that the Lee airshows really took off, attracting thousands of visitors to this annual event. In addition to the flypasts by modern and historic aircraft, for the public a trip up in a plane was a popular feature and afforded fantastic views of the Solent area. Although the aircraft on view were the real stars of the shows, it is a fact that many famous star names made guest appearances at the event, very often arriving by air. The list would include comedians Norman Wisdom and Dick Emery, but in 1994, to commemorate the fiftieth anniversary of D-Day, former 'Forces Sweetheart' singer Anne Shelton came to *Daedalus* to perform a nostalgic concert before a capacity audience. Sadly, it was Anne's last performance, for she died in 1994, and *Daedalus* died two years later in 1996.

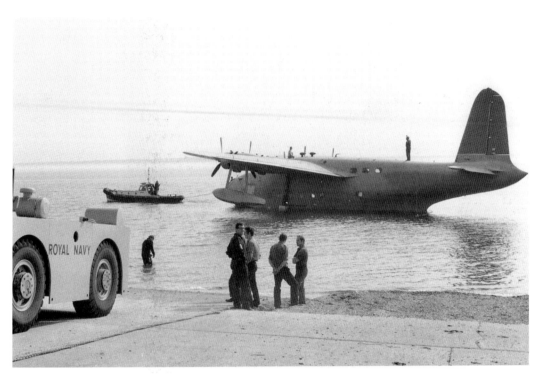

Above and below: In the June of 1981, the giant flying boat *Southern Cross* arrived at Lee for a full overhaul at HMS *Daedalus* with RN personnel providing technical advice. The Short Sandringham aircraft was at one time owned by Captain C. Blair, husband of film star Maureen O'Hara. During its stay, the boat was open to the general public.

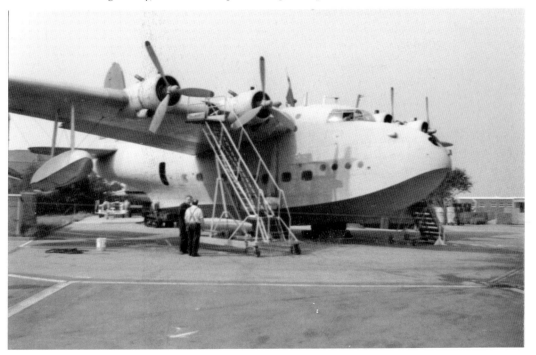

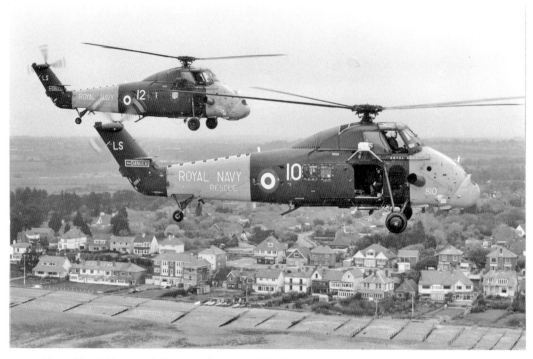

Above: Two RN rescue helicopters from *Daedalus* fly past nearby Hill Head in 1979.

Below: The HM Coastguard Search and Rescue Centre at Marine Parade West in March 2011, when it was under threat of closure. A helicopter pad is situated behind the building.

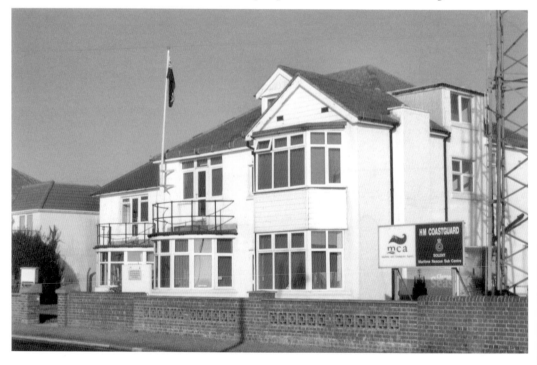

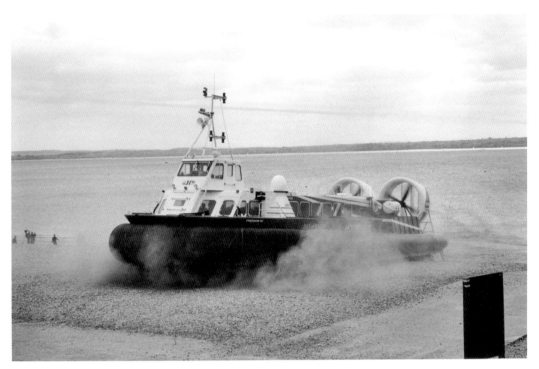

Above: For over forty years, hovercraft have been part of Solent life. The former air base at Lee currently houses a hovercraft museum accommodating the largest collection of the craft in the world.

Below: Every year the open days at Lee Hovercraft Museum attract thousands of visitors seeking to admire the craft or enjoy a short sea voyage on them.

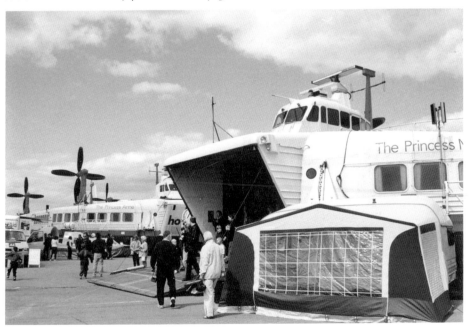

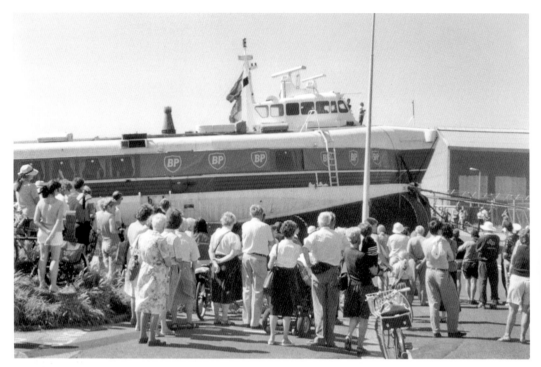

Above: In June 1994, hundreds of sightseers flocked to Lee waterfront to see the giant SRN4 hovercraft being towed up the slipway to the open museum.

Below: The Portsmouth Naval Gliding Club is based at the former *Daedalus* airfield and takes bookings for flights over the area. Having completed one such flight, the author is pictured here in 2002.

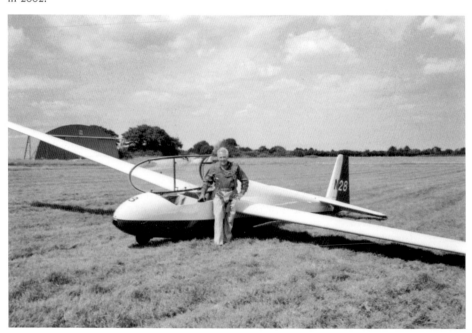

five

A Towering Attraction

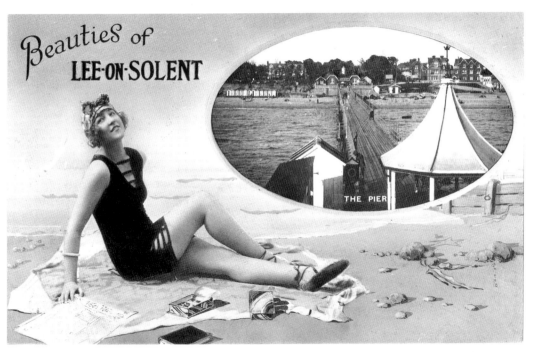

The year of 1935 was one of mixed fortunes for Lee, the bad news being that it lost its railway link that year, albeit goods traffic only, the passenger service having ceased in 1930. However, the good news in 1935 was that the town gained one of the most imposing leisure edifices to be seen along the South Coast, this being the Lee Tower complex. The whole structure comprised a cinema, dance hall, restaurant, lounge bars with a roof terrace, and a splendid 120-foot-high tower providing magnificent views across the Solent to the Isle of Wight.

The tower was described at its 1935 opening as 'A monument for all time'; sadly this was not to be and the complex only survived until the late 1960s, branded a white elephant and subsequently demolished. Older residents may still remember the Tower, but most younger residents and visitors have no idea that Lee once boasted such an imposing leisure complex on its seafront, for the site now houses a car park.

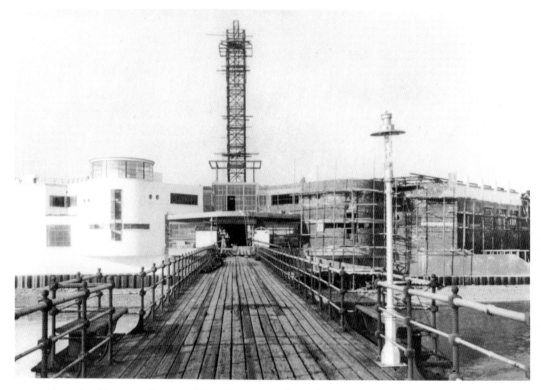

Above: In this 1935 photograph Lee Tower is well on the way to completion. On a technical note, the architects for the project were Messrs Yates, Cook & Darbyshire, the construction work was carried out by local builder Arthur Prestige, the steelwork was supplied by Dibben of Southampton, and all the bricks for the structure were made in kilns in Lee.

Below: View from the pier of the completed complex in 1937.

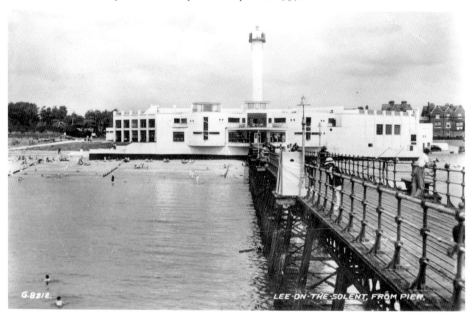

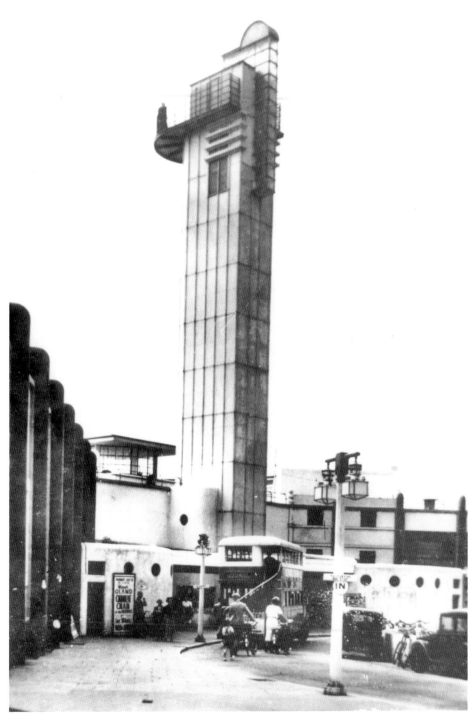

Captured in the late 1930s, Lee Tower dominates the Solent shoreline. A luxury passenger lift carried visitors up the tower to its 120-foot-high observation platform; it cost sixpence but was well worth it for the view.

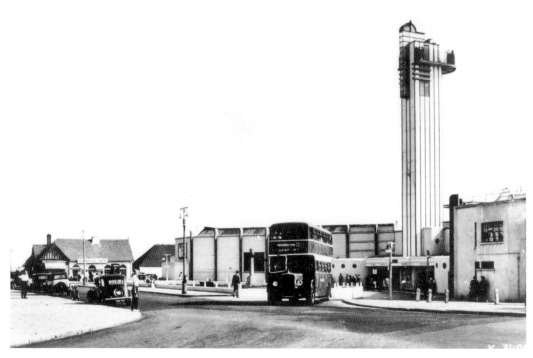

Above and below: Two more views of Lee Tower, one from Marine Parade and the other from the beach. Taken on the western side of the tower and pier, the lower, late 1930s photograph features the beach huts that once graced this area of the shoreline.

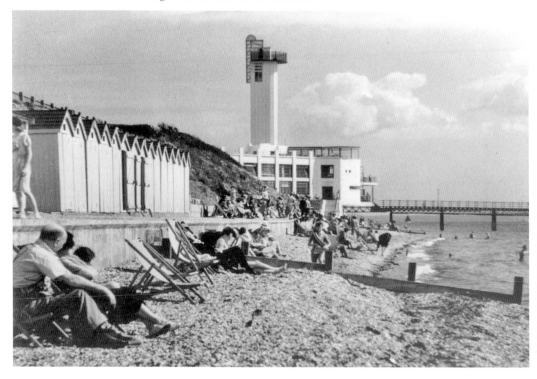

Right: The Lee Tower Cinema opened on
26 December 1935, the first main film shown was
Marry the Girl, starring Sonnie Hale (right). The
décor of this 900-seater picture house was quite
lavish, and admission prices ranged from 9*d* for
front stalls seats to a seat in the dress circle for
1*s* 10*d*.

Below: A 1930s close up of the entrance to the
tower and cinema; the film showing at the time
was *Charlie Chan at the Olympics*, starring
Warner Oland as the Chinese detective. This
unique little cinema closed in 1958 to be followed
by other entertainment ventures such as all-in
wrestling and ten-pin bowling, all of which were
relatively short-lived.

SONNIE HALE

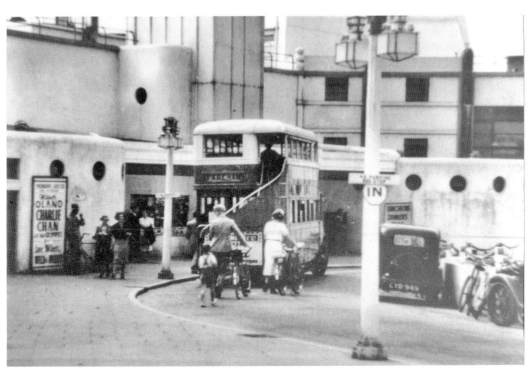

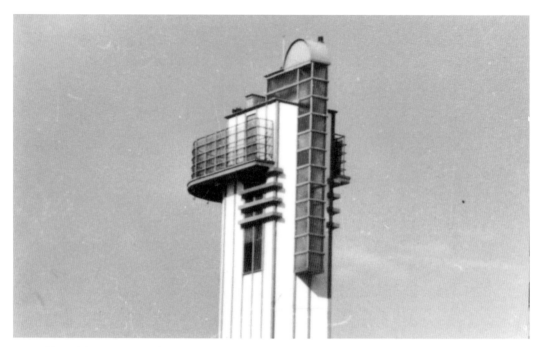

Above: The Lee Tower observation platform that afforded outstanding views of the Solent in the 1930s, although little did we realise that a few years later it would serve as a very useful landmark for the German Luftwaffe to navigate by during bombing raids on Portsmouth and Southampton.

Below: The resplendent Palm Court Café and Restaurant at Lee Tower, photographed soon after its opening in 1935.

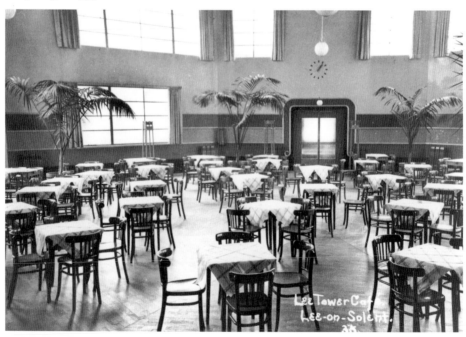

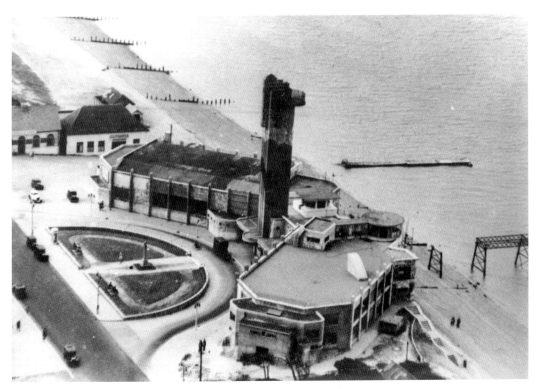

Above: It was not easy to disguise such an imposing edifice as Lee Tower, although, as seen here, it was coated with camouflage paint during the Second World War to make it less conspicuous.

Below: This viewcard, published in the post-war years, features the Tower still in its camouflage mode. During the war the complex was taken over by the military, and at one time was occupied by our American allies.

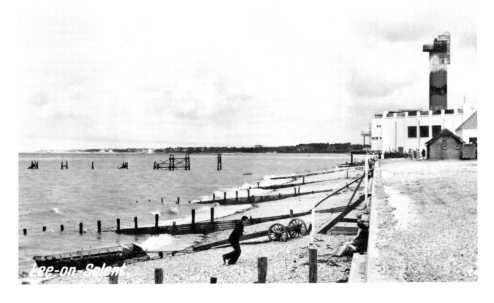

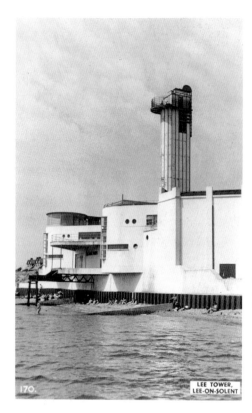

170.

LEE TOWER,
LEE-ON-SOLENT

Left: A seaside resort without a pier is rather like a cake without any icing, but after the war an effort was made to attract the visitors back, with the Tower complex being the main attraction.

Below: This aerial view of Lee-on-the-Solent demonstrates only too well the aftermath of the wartime breaching of the pier, leaving one to imagine what effect the rebuilding of the pier would have made on Lee.

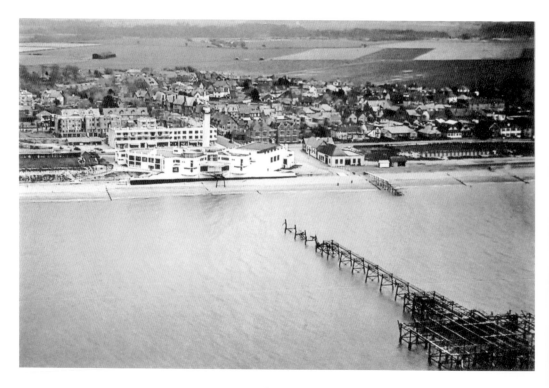

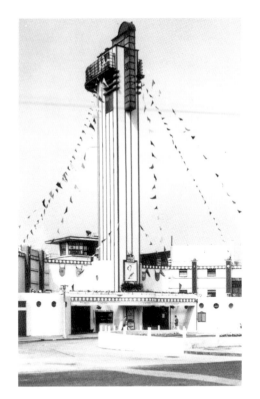 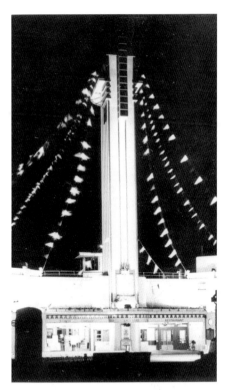

Above: The photograph on the left shows the Tower decorated for the 1953 Coronation celebrations; on the right is the same view taken at night.

Below: View of Lee Tower from the Solent in the 1960s.

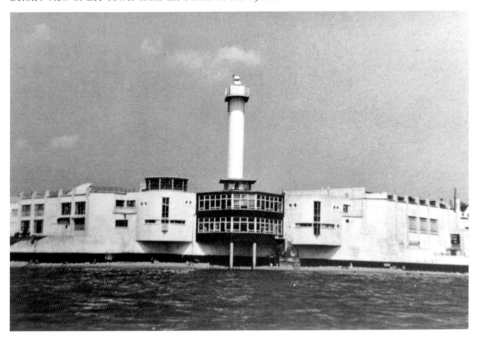

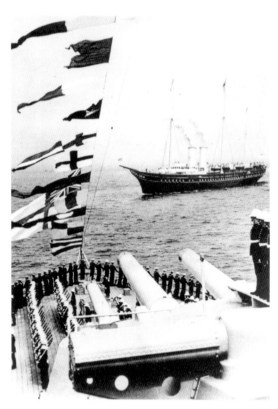

Left: The Royal Yacht *Victoria & Albert* in the Solent, as viewed from HMS *Queen Elizabeth* during the 1937 Fleet Review. This was the first major Fleet Review viewed from the Lee Tower observation platform after the entertainment complex was opened in 1935.

Below: The Royal Yacht HMS *Surprise*, as captured from HMS *Superb* during the 1953 Coronation Fleet Review. Such naval spectacles, as seen from Lee Tower, ended when the Tower complex was demolished in the late 1960s.

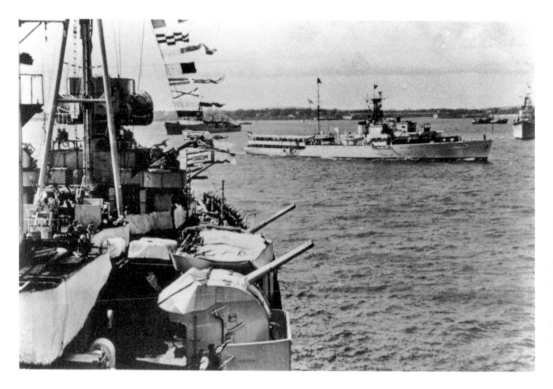

six

I Do Like to be Beside the Seaside

LEE-ON-SOLENT
CALLING.

SLIPWAY.

When the Robinson family first mooted the idea of developing Lee-on-the-Solent as a seaside resort, their dream was to create a watering place that would rival Bournemouth and Brighton. As history has shown, despite their valiant efforts this ambition was not fully realised and Lee has never catered for the 'Kiss-me-quick' hat contingent who come to the seaside to head for the nearest amusement park in order to embark on stomach-churning rides; neighbouring Southsea can readily cater for such needs. However, with its extensive beach and fine promenade, Lee is still a pleasant place to visit and a very desirable location to reside in, the latter confirmed by the considerable rise in population over the past thirty years or so. As the chief objective of this book is to provide a reminder of Lee's past, I have dedicated this section to pleasurable pastimes, but of course many of the activities featured, such as golf, tennis, swimming, fishing and sailing, can still be enjoyed today.

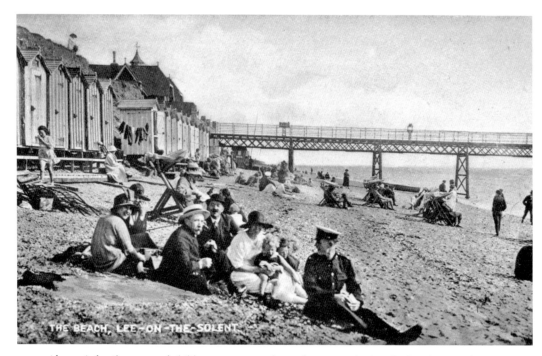

Above: A family group of children, parents and grandparents enjoying the beach around 1930, before Lee Tower was added to this nostalgic scene.

Below: A mid-1920s view of the beach and promenade from the end of the pier, captured in the days when our summers seemed to last forever.

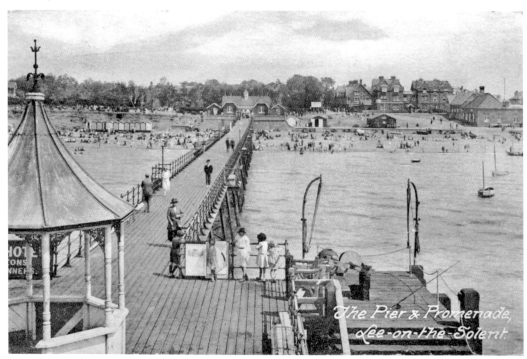

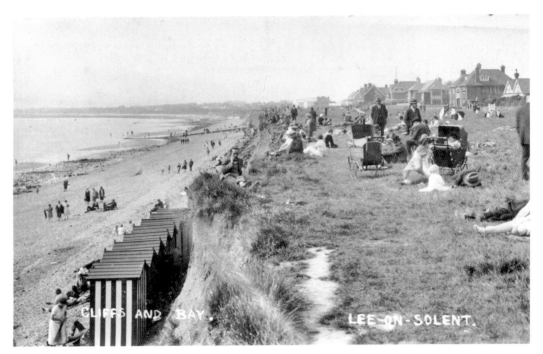

Above: Along the clifftop, looking west towards Hill Head. This extensive grassed area was, and still is, ideal for family picnics, but I would not advise having the babies' prams so close to the cliff edge, as in this 1920s beach photograph.

Below: A lone visitor admires the yachts in this photograph of *c.* 1930, taken before the pavilion at the end of the pier was destroyed by a fire in 1932.

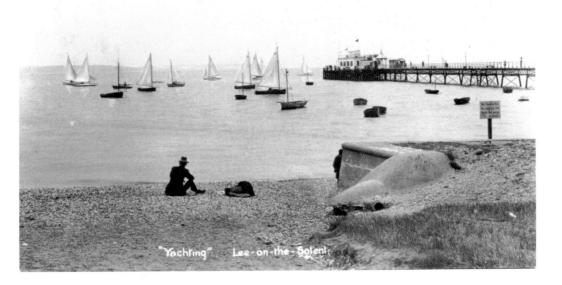

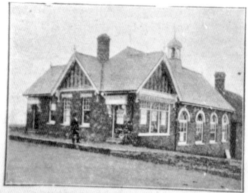
Above: Estate agent Samuel Gale's office at Marine Parade in 1905. Agents such as Sam Gale and Frederick Flower played an important role in the development of Lee.

Below: For moving in or out of properties, one usually employs the services of a removal firm; for this, the known name was that of Joe Badland, who until the 1960s had his offices in Lee High Street.

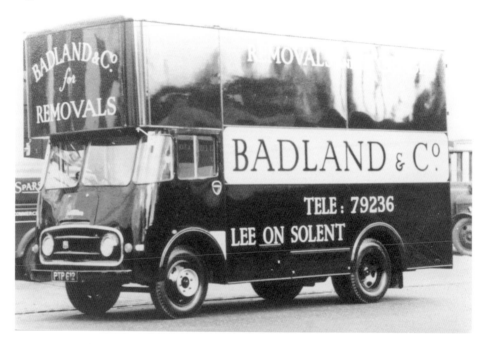

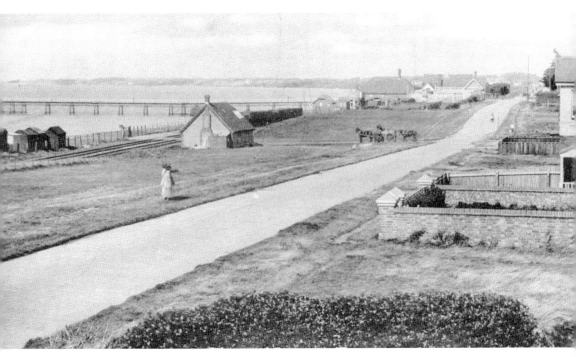

Above and below: The top view of Marine Parade East was captured around 1910, but in the lower picture we move on thirty years to find that Lee Tower and the Spinnaker Café have been added to the same viewpoint. This Art Deco-style café was demolished in recent years and replaced with seafront flats.

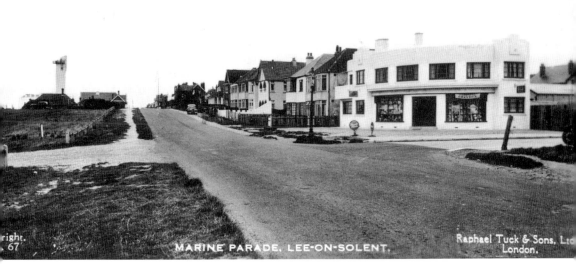

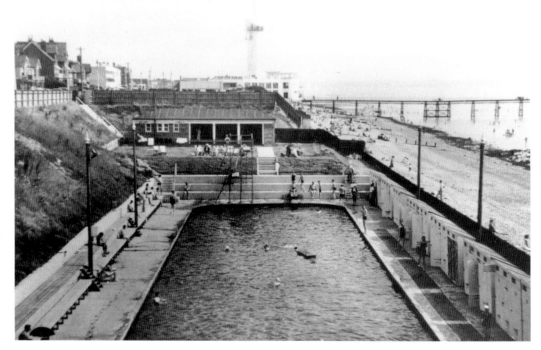

Above and below: Although swimming in the sea was free, from the early 1930s one could enjoy the luxury of Lee open-air swimming pool. The top photograh was taken in the late 1930s, after the Lee Tower complex had been opened. The lower photograph features a water polo match in progress from the same period.

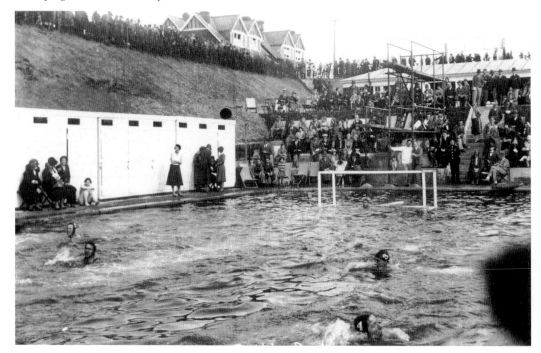

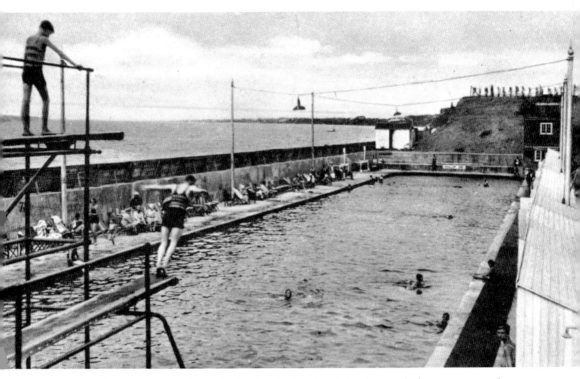

Above and below: The top picture highlights the height of the diving platform at Lee pool, definitely not for the faint-hearted. The lower photograph was taken with the diving boards removed. A number of years ago, the pool was closed and filled in for a children's playground adjacent to the Waterfront Brasserie.

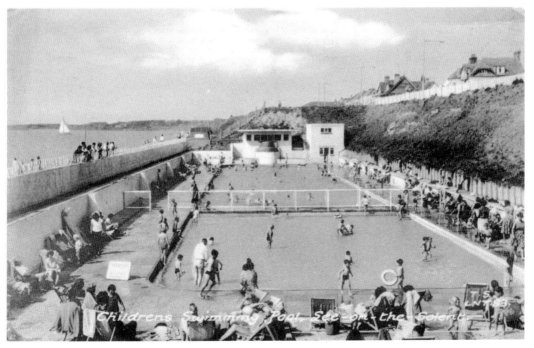

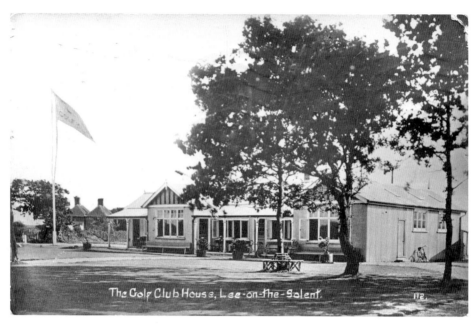

The Golf Club House, Lee-on-the-Solent.

Above: Lee-on-the-Solent Golf Club in the 1920s. This popular club was founded in 1905 and is still flourishing over 100 years on. Around 1980 the old clubhouse was replaced with a more modern structure.

Below: Five veteran Lee Golf Club members pose for a historic photograph in the June of 1977.

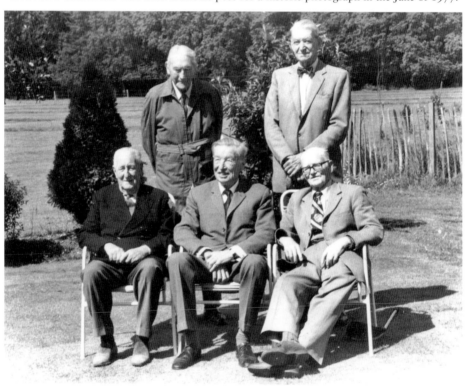

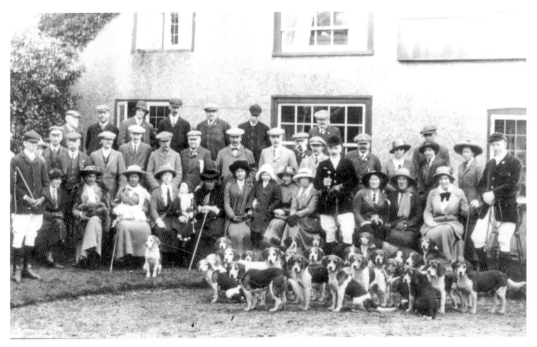

Above: Ready for the hunt. The Fareham and Gosport Beagles gathered outside the Victoria Hotel in Manor Way, *c.* 1910. The hounds' kennels were at nearby Peel Common.

Below: Lee-on-the-Solent FC in 1948. Usually played on Sundays, home matches took place on Lee Recreation Ground.

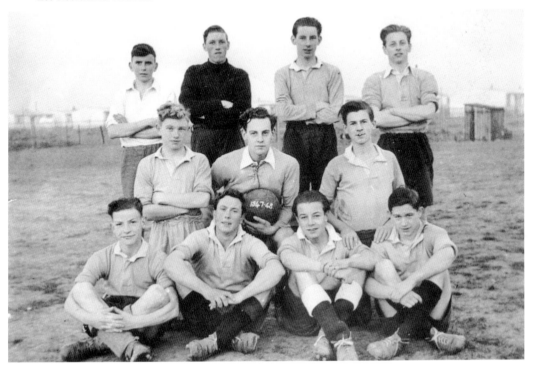

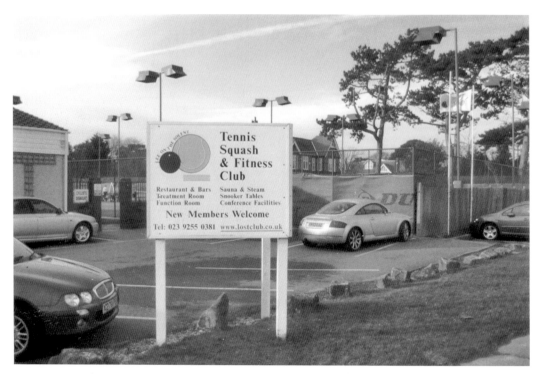

Above and below: Lee-on-the-Solent Tennis, Squash & Fitness Club in Manor Way. This popular club, currently boasting over 1,800 members, was founded in 1908 with two tennis courts on the seafront, but moved in 1919 to its present site, where it has six tennis and six squash courts, plus a gym and bar.

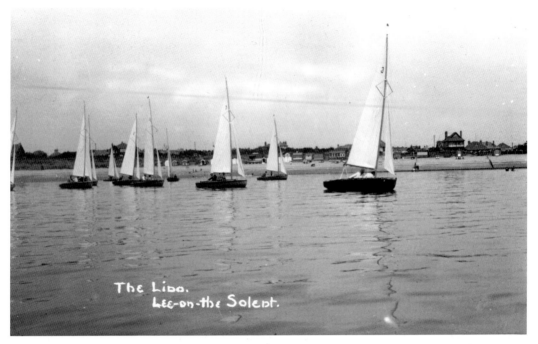

Above: The long-established Lee Sailing Club has its compound at Elmore, with a large clubhouse nearby at Marine Parade East. When this 1920s sailing photograph was taken, this end of the shore was referred to as 'The New Lido'.

Below: A post-war view of the beach at Elmore; Lee Tower can be seen still in its wartime guise.

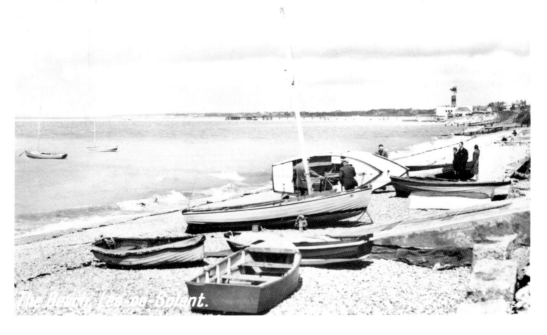

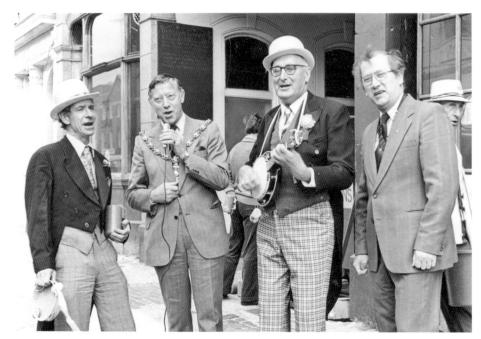

Above: Mayor of Gosport Ron Dimmer at the microphone, helping the local Lions Club to raise funds for charity in 1979. Ron, born and bred in Lee, represented the town for many years on the Borough Council.

Below: Gosport Mayor Doug Hope making a staff retirement presentation in 1980. This photograph is unique in featuring nine former mayors, including three who represented Lee: Jack Eales, Ron Dimmer and Gordon Flory.

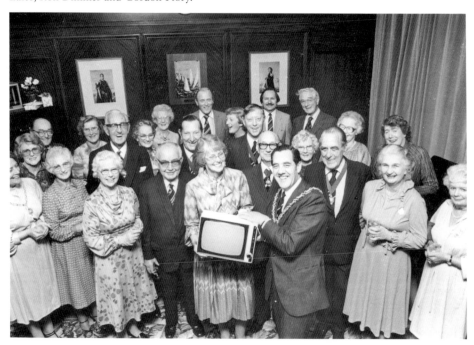

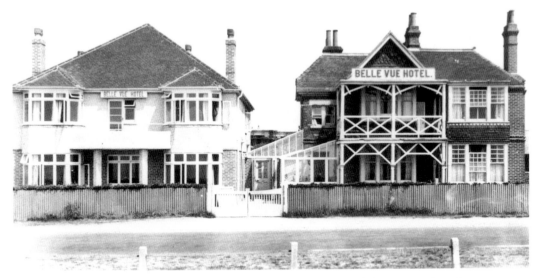

Above and below: The Belle Vue Hotel in Marine Parade East graced the Lee waterfront for many years; the top photograph dates from the 1920s and the lower was taken in 2002, prior to this popular pub and restaurant being demolished and replaced by the Anchorage Court retirement flats.

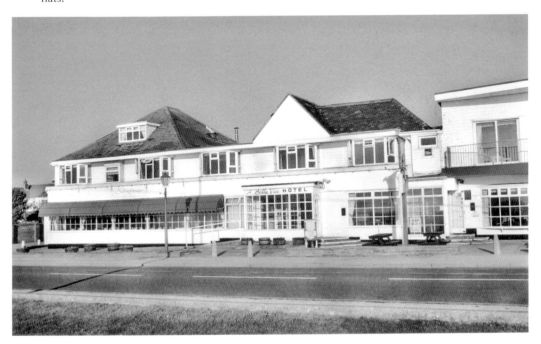

Above: Named in honour of the famous Fairey aircraft so closely associated with nearby HMS *Daedalus*, the Swordfish Hotel at the western end of Lee was demolished in the late 1990s and replaced by a development of luxury houses and flats.

Below: Affording splendid views of the Solent, the Old Ship still serves good food and ale, as it has done for several decades on Lee's waterfront.

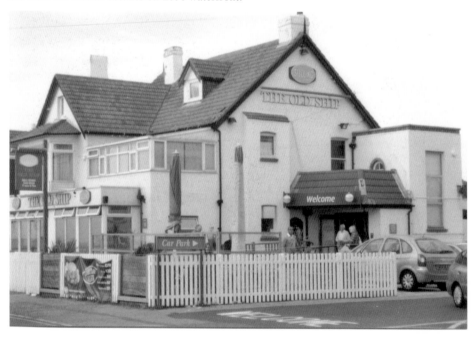

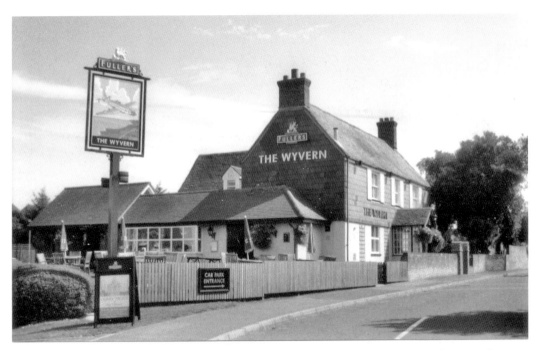

Above: The Wyvern pub, on Lee's northern border, was converted from an old farmhouse in the late 1970s to cater for the extensive housing development which has built up over the past thirty years.

Below: Ross House at the far western end of Lee; once a residence for succeeding commodores of HMS *Daedalus*, this grand house was demolished in 2000 to be replaced by a block of seafront flats.

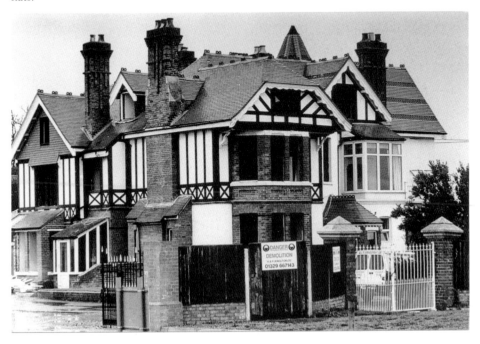

Having a Good Time.

Wishing You Were Here.

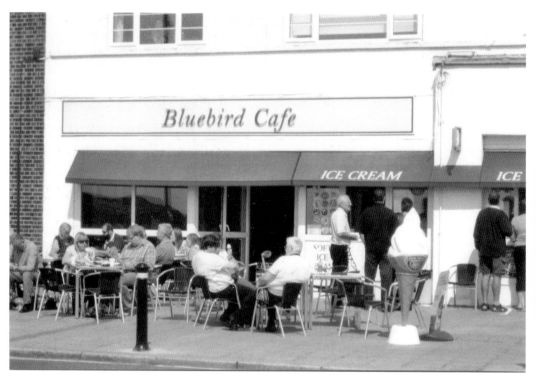

Above and below: The Bluebird Café on Marine Parade, and the Lee Bookshop in the High Street. Both of these businesses were established in the 1930s and are pictured still serving their loyal customers in 2011.

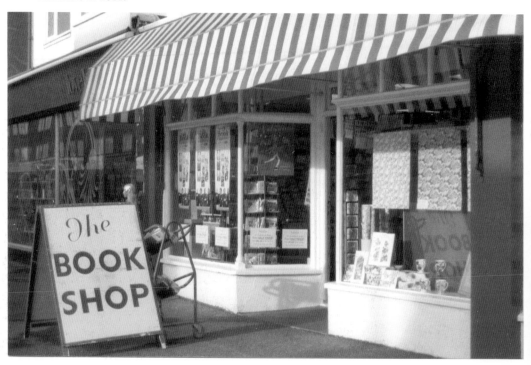